TRAINS AROUND EASTLEIGH AND SOUTHAMPTON

JOHN JACKSON

First published 2023

Amberley Publishing
The Hill, Stroud
Gloucestershire, GL5 4EP

www.amberley-books.com

Copyright © John Jackson, 2023

The right of John Jackson to be identified as the Author of this work has been asserted in accordance with the Copyrights, Designs and Patents Act 1988.

ISBN 978 1 3981 0900 1 (print)
ISBN 978 1 3981 0901 8 (ebook)

All rights reserved. No part of this book may be reprinted or reproduced or utilised in any form or by any electronic, mechanical or other means, now known or hereafter invented, including photocopying and recording, or in any information storage or retrieval system, without the permission in writing from the Publishers.

British Library Cataloguing in Publication Data.
A catalogue record for this book is available from the British Library.

Origination by Amberley Publishing.
Printed in the UK.

Contents

Introduction	4
Map of Railways Around Eastleigh and Southampton	7
Eastleigh – Setting the Scene	8
Eastleigh – Passenger Services from British Rail to Private Ownership	11
Eastleigh – From Nationalisation to Privatisation	21
Eastleigh – Freightliner Services	32
Eastleigh – DB Cargo Services	36
Eastleigh – GB Railfreight (GBRf) Services	44
Eastleigh – Colas Rail Services	54
Eastleigh – Other Operators' Services	58
Eastleigh Arlington	60
Southampton – Around the City and Suburbs	69
Freightliner's Hub at Southampton Maritime and Millbrook	85

Introduction

I was just a fledgling teenager when I made my first visit to the station at Eastleigh. It was a Saturday in the autumn of 1966 and just a few months before steam traction was to be totally eliminated from the South West Main Line (SWML).

My trusty notebook covering that day records the passing of express services still in the hands of steam engines including the likes of No. 34001 *Exeter* and No. 34098 *Templecombe*. The southbound Bournemouth Belle was in the hands of 'Merchant Navy' class No. 35007 *Aberdeen Commonwealth*, while a standard Class 5, No. 73113 *Lyonnesse*, worked a stopping service to Bournemouth. On the diesel front, several 'Crompton' Class 33 diesel locomotives and a couple of Class 73 electro-diesels were also noted, together with a 'Warship' simply listed in my book as 'regrettably, unidentified'.

Sadly, I have no photographic evidence of that day, but I was not to know then that the Eastleigh and Southampton area would become one of my most frequently visited locations, particularly in the last thirty years and counting. Hopefully, the railway variety featured on the pages that follow shows just why. Most of the photos featured show the nationalised rail scene in the run up to privatisation and the quarter of a century since.

In addition to the changes brought about by rail privatisation in the mid 1990s, the Cromptons and English Electric Type 3s have given way to their private operators' replacements, including the ubiquitous Class 66s. The longevity of the Class 73 electro-diesels is evidenced by their continued use throughout the period covered in this publication.

Today, four of the five major privatised freight operators make regular appearances in the Eastleigh and Southampton area, with Freightliner, DB Cargo and GB Railfreight all involved in goods movements to and from the nearby docks. All three, together with Colas Rail, also provide an important role in operation of infrastructure workings on behalf of Network Rail. Finally, Direct Rail Services have made appearances, particularly on Network Rail test trains in recent years.

On the passenger front, the Battle of Britain and West Country steam locos may have gone half a century ago, but in today's privatised railway, both Southwestern Railway (SWR) and CrossCountry Trains operate regular long-distance services through the area.

With the passing of steam in 1967, third rail electrification of the main London to Bournemouth line was introduced almost immediately, with the Portsmouth line electrification added a quarter of a century later.

Main line SWR services today link London's Waterloo station with Southampton, Bournemouth and Weymouth, as well as a regular service to Portsmouth routed via Eastleigh and Hedge End. CrossCountry trains also link Southampton and Bournemouth with Reading, Oxford and Birmingham New Street and onwards to the north of England. In addition, SWR, together with local competitors Southern, operate shorter-distance passenger services in the area. This includes the service between Eastleigh, Chandler's Ford and Romsey. This section of line is notable in that passenger services were withdrawn back in 1969, only to be reinstated in 2003. It is not electrified and is, therefore, the only diesel-hauled service within the local area.

Introduction

As I write these notes there remains the possibility of the reinstatement of a local passenger service between Southampton, Marchwood and Fawley. This would partially help to alleviate the road traffic volumes on the busy A326 in the area, particularly during peak periods. The road also gives oil tankers road access to the refinery at Fawley since the cessation of railborne oil traffic in the early 1970s.

A quick glance at the map at the beginning of the photo section shows the prominence of Eastleigh station as a major railway junction. The Hampshire town is around 65 miles from London's Waterloo terminus, with the central station at Southampton a further 5 miles to the south-west. Beyond Southampton, the SWML continues a further 50 or so miles to the Dorset terminus at Weymouth, with Bournemouth situated roughly halfway between the two.

The Eastleigh and Southampton area offers the rail enthusiast a great deal more. The former Southern Railway workshops at Eastleigh, for example, were granted a new lease of life in 2004. Drawing on the skills base dating back to the nationalised days, Arlington Fleet Services was formed that year, offering a diverse range of services to the now privatised industry through many aspects of rail vehicle maintenance. As a result, the former works reopened in 2006 offering services ranging from heavy repairs to paint shop facilities, as well as stabling facilities for rolling stock up to 250 metres in length.

The main yard on the eastern side of the London-bound main line at Eastleigh has also seen many changes over the years, with GB Railfreight the current occupants. The yards handle a wide range of wagons, particularly as a base for Network Rail infrastructure trains working across a large area of southern England. As well as providing loco stabling facilities, the sidings adjacent to Eastleigh station platforms are also alongside the ballast virtual quarry based here.

Several of the road-facing rooms at the Travelodge opposite the station entrance offer a vantage point for viewing the railway scene around Eastleigh described here. A number of photos in the pages that follow were taken from this location. The Campbell Road bridge and the footpath nearby also offer a view of the main line, the former traction depot sidings and the Arlington complex.

While it falls outside the scope of this publication, the town's Lakeside Steam Railway also deserves a mention and is worth a visit. This miniature railway has been in operation for over thirty years.

On the boundary of the town of Eastleigh and the city of Southampton lies Southampton Airport. The nearby railway station, served by British Rail from 1966, was renamed Southampton Airport and, later, Southampton Airport Parkway in 1994.

Between the sirport station and Southampton's Central station is the electric multiple unit depot at Northam. Since 2003, this has been the Siemens base for stabling and servicing of the Class 444 and Class 450 units on SWML services, currently operated by South Western Railway.

Southampton is a major port for both passenger and cargo traffic, with its origins dating back to the days of Roman occupation of the UK. It has long been regarded as the UK's gateway to the world, particularly before the advent of air travel. Today, it is the UK's second busiest container port, behind Felixstowe, handling 2 million Twenty Foot Equivalent Units (TEU's) per annum. The subject of railborne container handling was covered in much more detail in my earlier Amberley publication *Containers by Rail in the UK*. Latest industry figures suggest that one in four containers arriving at UK ports move onwards via the UK rail network. In addition, the docks at Southampton are the number one port for automotive handling, involving close to a million vehicles per year.

The majority of this container traffic is operated by Freightliner, which was formed by a management buyout team in the mid-1990s at the time of rail privatisation. The company is currently a wholly owned subsidiary of American company Genesee & Wyoming. At present,

it boasts a fleet of over 200 locos and nearly 4,000 wagons. Their rail hub serving the port is located to the west of Central station, at Southampton Maritime, close to Dock Gate 20, with a smaller facility for wagon storage and maintenance at nearby Millbrook. Freightliner has just been named 2022 Rail Freight Operator of the year, the fifth time since 2016 they have been recognised.

As already mentioned, three of the four other railfreight operators, namely DB Cargo, GB Railfreight and Colas Rail, complete the freight scene, with each company operating a variety of services in the area.

In the pages that follow, we take a detailed look at the rail scene in the Eastleigh and Southampton area from the time of rail privatisation, in the early to mid-1990s, to the present day. Finally, I hope you enjoy browsing through these pages as much as I have enjoyed compiling them.

Map of Railways Around Eastleigh and Southampton

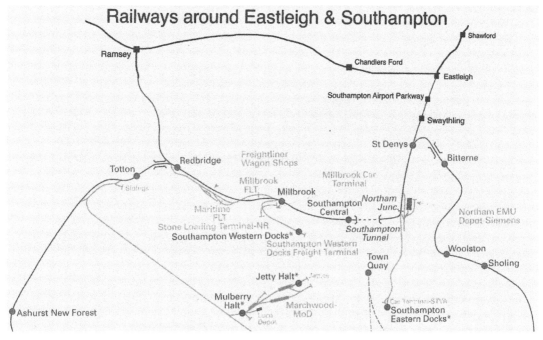

Map showing today's railway lines in the Eastleigh and Southampton area.

Eastleigh – Setting the Scene

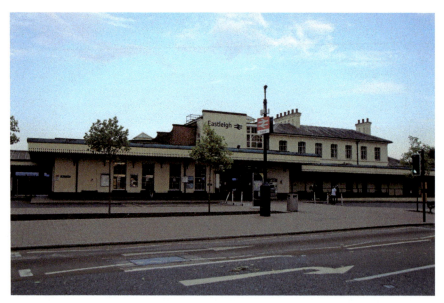

Our journey around this area of Hampshire commences at Eastleigh station. It was originally called Bishopstoke when opened by the London & South Western Railway (LSWR) in 1839, changing to the name of Eastleigh in the 1920s. This view of the station forecourt was taken in 2018, following improvements carried out a few years earlier.

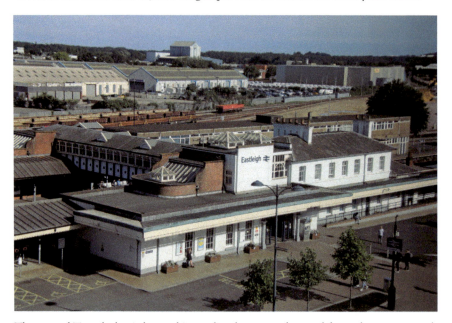

The central Travelodge is located immediately across the road from the station, with several roadside rooms offering views of the railway layout in the area. This is the view of the station front from one of the hotel's windows, taken in 2020.

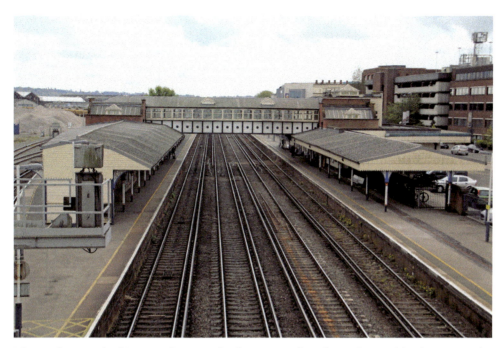

This is the view looking south to Eastleigh station taken from the road bridge on nearby Bishopstoke Road. The station consists of three platforms, with the LSWR lines towards Southampton passing straight through the station, and the line to Portsmouth, via Hedge End, veering to the left. The LSWR main line towards London Waterloo and the branch to Chandler's Ford and Romsey are behind the camera.

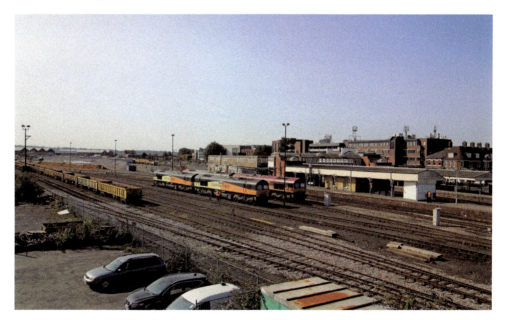

For many years, there has been a locomotive stabling point to the east of the station's island platforms. This 2020 photo was also taken from Bishopstoke Road and shows Class 66 locomotives operated by both DB Cargo and Colas Rail stabled.

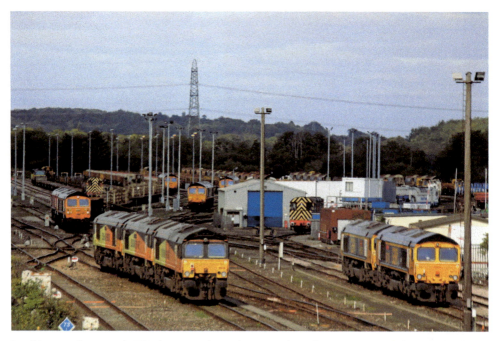

Looking north, towards Winchester and London Waterloo, the main East Yard at Eastleigh can also be seen from the same road bridge. With the LSWR main line out of view on the left, this photo shows the extensive sidings in the area, with locos from many different rail operators on view.

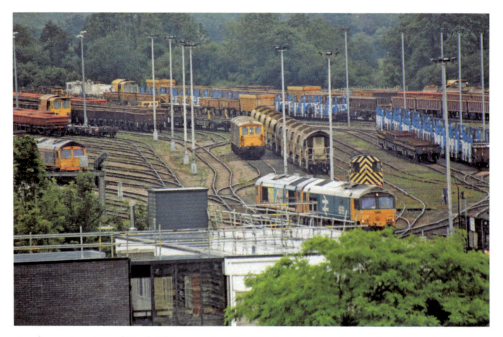

An alternative view of Eastleigh's extensive East Yard can be seen from selective roadside rooms at the nearby Eastleigh Central Travelodge. On 28 June 2021, a pair of GB Railfreight Class 66 locomotives, Nos 66720 and 66779, are seen shunting in the yard.

Eastleigh – Passenger Services from British Rail to Private Ownership

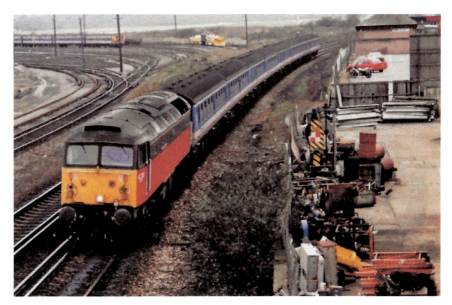

In the 1990s, Class 47 locomotives hauling Network SouthEast coaching stock were regular visitors through Eastleigh. On 22 February 1992, No. 47703 *The Queen Mother* approaches the station on a northbound service. This loco carried the dedicated Rail Express Systems livery at that time.

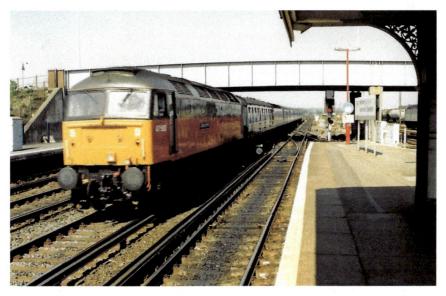

The same livery was also carried by sister loco No. 47582 *County of Norfolk* when seen heading in the opposite direction passing through Eastleigh in August 1991.

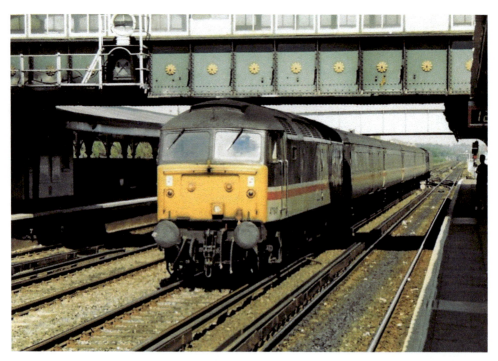

A little later the same day, an InterCity service is seen heading south on the South Western Main Line through Eastleigh, bound for Poole. The train is hauled by InterCity 'Swallow'-liveried No. 47847. This 1964 built loco survives under the ownership of Harry Needle and is currently stored at Worksop.

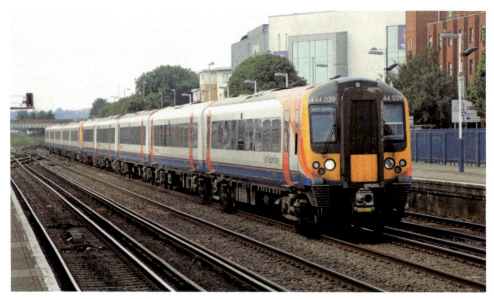

A quarter of a century later and express services between Weymouth, Bournemouth, Southampton and London Waterloo are in the hands of private operator South Western Railway (SWR). On 14 July 2018, two of their five-car Class 444 electric multiple units, with No. 444039 leading, head north through Eastleigh on a service to London Waterloo.

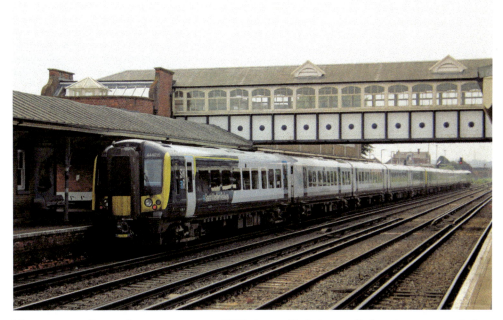

The corporate livery of current operator, SWR, is steadily being applied to that company's fleet of Class 444 units. A ten-coach rake stands at Eastleigh station on 27 June 2021, with unit No. 444015 nearer the camera.

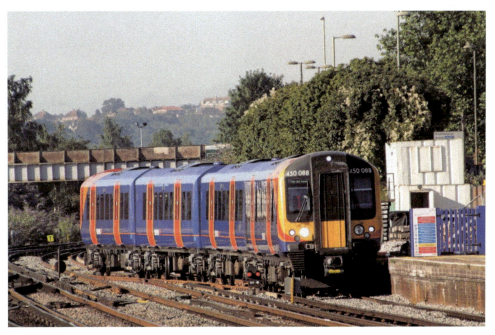

Semi-fast services in the area are operated by four-coach Class 450 units, alongside the five-car Class 444 units. On 16 July 2014, No. 450088 enters the London-bound platform on a service to London Waterloo. At that time, the service was operated by the previous franchise operator, South Western Trains (SWT). The Stagecoach-owned SWT was to lose the franchise in 2017.

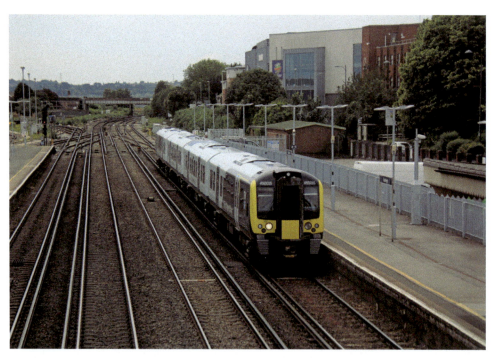

As already mentioned, the fleet of SWR electric multiple units (EMUs) are steadily being outshopped in the company's own livery, including sister unit No. 450015. It is seen arriving at Eastleigh on 26 June 2021 on a Waterloo service.

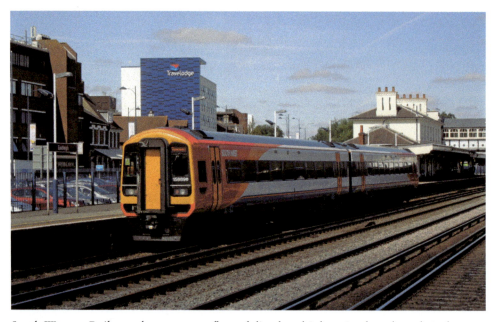

South Western Railway also operate a fleet of diesel multiple units, based on their depot at Salisbury. Their duties include the Romsey, Southampton and Salisbury circular service, part of which covers non-electrified lines. On 30 August 2013, No. 158890 calls at Eastleigh on a service to Romsey. The Travelodge mentioned in the introduction can be seen behind the unit.

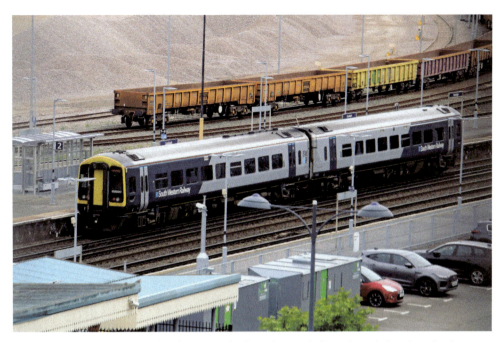

SWR's corporate livery is also being applied to their Salisbury-based diesel multiple units, including No. 158890. In its new colours, it is seen leaving Eastleigh station bound for Southampton Central in June 2021.

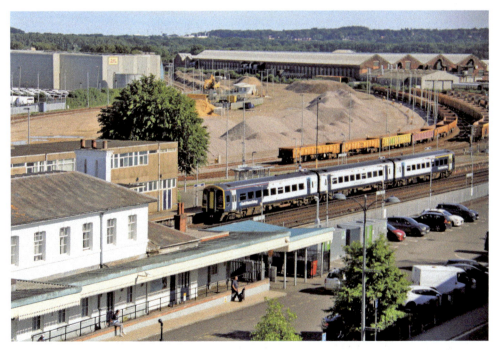

While two-car Class 158s are routinely used on these passenger services, SWR three-car Class 159s are also occasionally seen in the area. One of these, No. 159010, heads south through the station in June 2021.

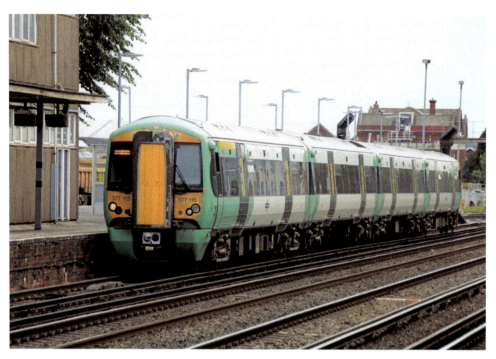

Rival operator Southern also operates a limited number of services from Eastleigh eastwards towards Portsmouth and Brighton. Their four-car Class 377 electric multiple unit, No. 377115, reverses at Eastleigh before heading eastbound.

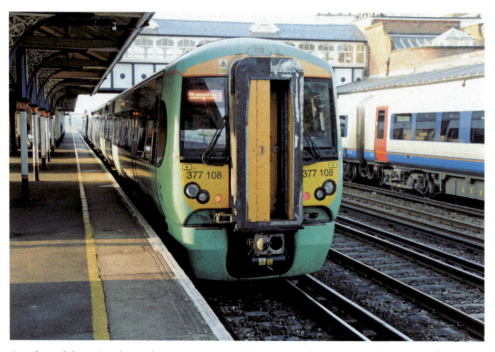

Another of these Southern electric units, No. 377108, stands at Eastleigh on 3 October 2015. It is seen while reversing to head in the opposite direction towards Southampton Central.

Eastleigh – Passenger Services from British Rail to Private Ownership

First Great Western services between Portsmouth Harbour and Cardiff are occasionally routed through Eastleigh, usually as a result of engineering works affecting the direct route along the coast. In July 2018, their three-car diesel multiple unit, No. 158953, is seen leaving the platform.

Passenger operator CrossCountry Trains is responsible for longer-distance services between Manchester Piccadilly and Bournemouth. These intercity services have broadly replaced the Class 47s and coaching stock that operated in British Rail days. These workings are currently in the hands of four- and five-car 'Voyagers'. On 14 July 2018, No. 221121 heads north through Eastleigh on the Up (London-bound) main line.

While these CrossCountry services do not routinely call at Eastleigh, their Voyagers stable overnight at the nearby depot, resulting in empty stock moves within the station platforms, particularly at the beginning and end of the working day. On the morning of 16 July 2018, four-car unit No. 220033 is reversing in the station. It will head to Bournemouth in order to start its day's passenger duties from there.

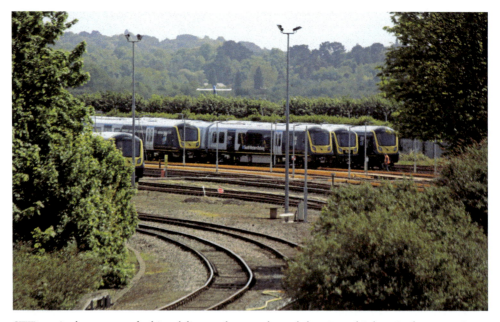

SWR are in the process of taking delivery of a new class of electric multiple units for use on inner suburban services, closer to London. The former depot at Eastleigh has been housing a number of these Class 701 electric units during their testing period. On 13 May 2022, the line up of these units included Nos 701512, 701013, 701030 and 701031, with one unit number unidentified.

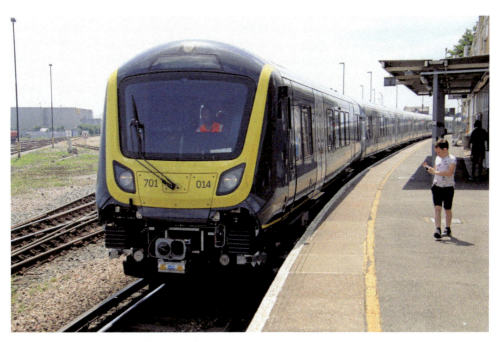

On the same day, No. 701014 is seen reversing in the platform at Eastleigh station. It has just returned from a test run on the LSWR main line. These Class 701 'Arterio' units are currently under construction by Alstom at their Derby works.

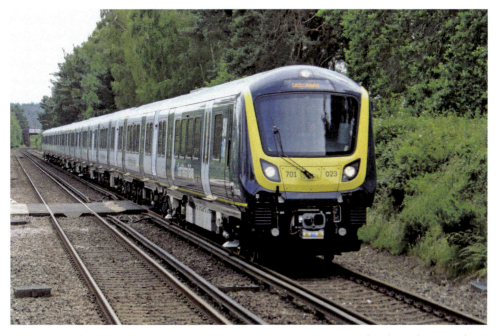

At the time of writing, these units are yet to enter passenger service. They have, however, been accumulating mileage on test runs either to London Waterloo or towards Southampton and Bournemouth. On 22 June 2022, No. 701023 is returning to Eastleigh from Bournemouth, when seen near Beaulieu Road station.

On 15 July 2018, the pattern of routine passenger services was broken by the returning empty coaching stock from the previous day's GB Railfreight staff charter at Peterborough. The freight operator had earlier used a pair of its own Class 73 locomotives to haul the working. The pairing of No. 73961 *Alison* and No. 73963 *Janice* were returning the stock to Eastleigh for stabling.

Eastleigh – From Nationalisation to Privatisation

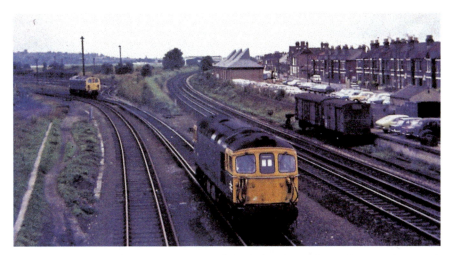

Eastleigh depot had a long association with both diesel and electric locos in the British Rail days prior to privatisation, including Class 74 electric locomotives. On this day in 1977, six of the ten Class 74s were recorded, with just one, No. 74007, moving that day, albeit in a depot shunting move. Crompton Class 33 No. 33110 waits patiently for its own turn to run on to the depot.

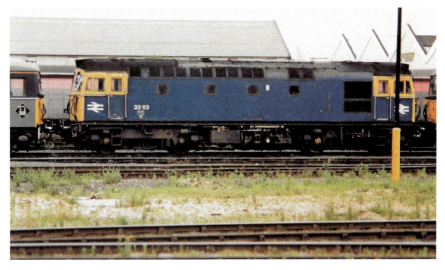

The Class 74 electrics may have been withdrawn on mass at the end of 1977, but the Crompton Class 33 diesel locomotives were to remain in use on the former Southern Region through to the days of rail privatisation in the mid-1990s. Class 33 locomotive No. 33113 stands in a loco line-up on Eastleigh's stabling point in 1991. Many enthusiasts will recall the days when just about every loco in the UK carried this plain BR blue livery.

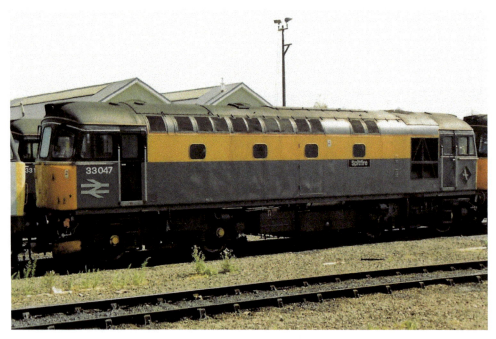

By the 1990s, many of these surviving Class 33 locomotives were reliveried in Civil Engineers Department house colours, including No. 33047. The loco was named *Spitfire* at Eastleigh depot in April 1991 and is seen on the stabling point a few months later. It was to be scrapped at Eastleigh in 1997.

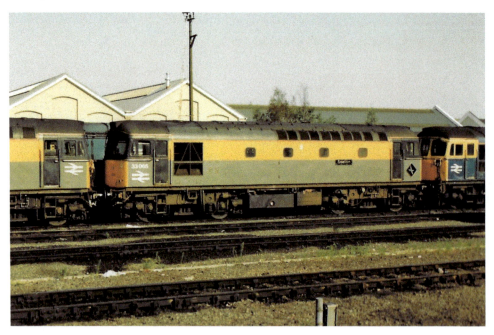

This Civil Engineers livery came to be nicknamed 'Dutch' because of its similarity with that of the Dutch Railways. On 31 August 1991, No. 33065 *Sealion* was also stabled at Eastleigh. This loco has survived and is preserved on the Spa Valley Railway at Royal Tunbridge Wells in Kent.

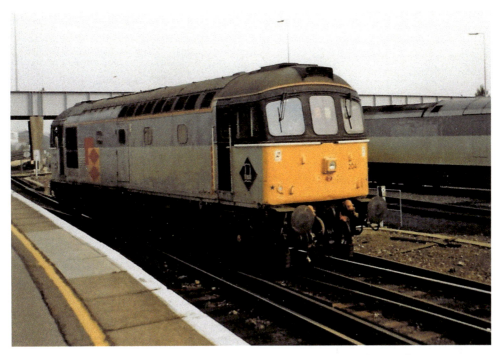

By 1994, Railfreight Distribution livery had been applied to sister Class 33 loco No. 33204. While it was more frequently to be found in the Dover area, it had arrived at Eastleigh on Saturday 24 September that year for possible weekend infrastructure duties.

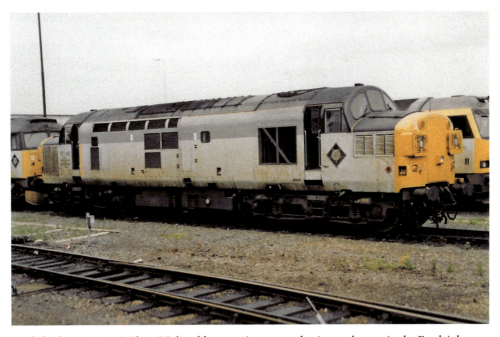

English Electric Type 3 Class 37 diesel locomotives were also in regular use in the Eastleigh area. On 20 July 1992, Railfreight-liveried No. 37045 was one of the stabling point's residents. The loco survived until being cut up in 2003.

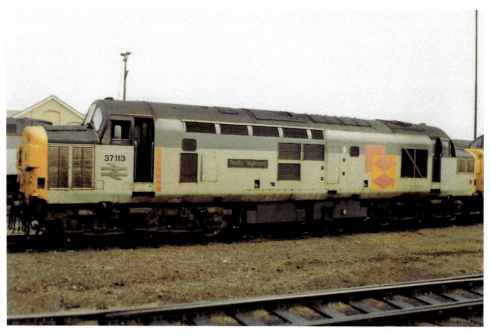

Earlier that year, the loco holding sidings were home to Railfreight Distribution's No. 37113 *Radio Highland*. The loco would shortly return to more familiar duties with a transfer back north to Scotland's Highland workings once again, to be based on Inverness depot.

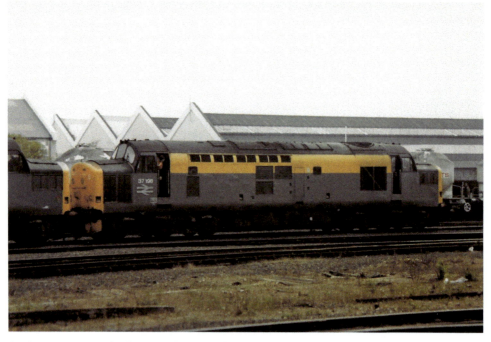

A 1994 visit to Eastleigh was to be rewarded with a wide range of locomotive liveries on the 'English Electric Type 3' Class 37 locos that were stabled that day. These included 'Dutch'-liveried example No. 37198, seen on the stabling point on 24 September that year.

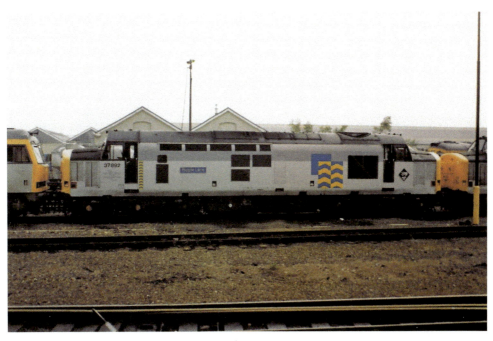

In the same line up of locos that day in 1994 was No. 37892 *Ripple Lane*. The loco had recently received the Railfreight Petroleum sector colours. At the time, these Class 37s could be found on oil workings in the Southampton area, including from the nearby terminal at Fawley. This 1963-built diesel was to survive until 2008 before being scrapped at EMR, Kingsbury.

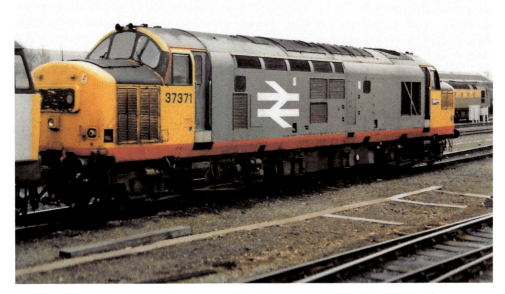

Another livery variation, 'Red Stripe' Railfreight, was carried by No. 37371 when seen on Eastleigh stabling point on 22 February 1992. My next observation of this loco was to be approximately six months later, on a tank working from Fawley to Tavistock Junction, Plymouth.

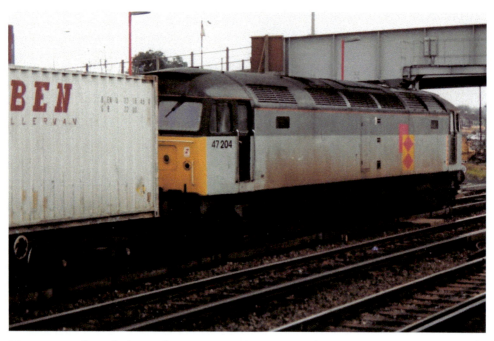

The extensive fleet of Class 47 locomotives were seen on both passenger and freight services in the area. They were regular performers on the regular Freightliner workings to and from the docks at Southampton. Loco No. 47204 is seen passing through Eastleigh station on a typical liner working in 1992.

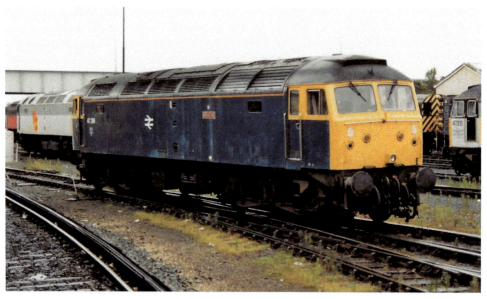

Sister loco No. 47299 is seen approaching the stabling point at Eastleigh in October 1991. The loco briefly carried the unofficial name *Ariadne* during that year. This loco was often referred to as cursed or jinxed, even being renumbered from 47216 following a clairvoyant's prediction of a serious accident to a locomotive carrying the number 47216. It was to be reduced to a pile of scrap by the end of 1999.

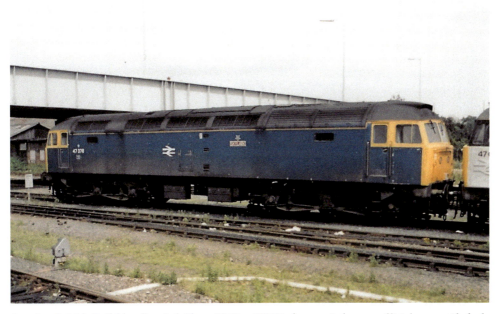

Another British Rail blue-liveried Class 47 No. 47376 also carried an unofficial name: *Skylark*. These locomotive namings were a local initiative by Sheffield's Tinsley depot staff involving locos allocated there towards the end of the 1980s. This Eastleigh stabling point view of No. 47376 was on Monday 20 July 1992 after the loco had been used on weekend infrastructure work.

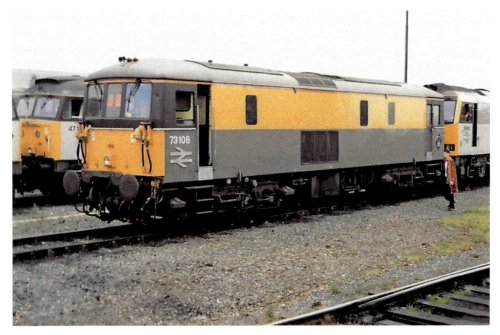

The former Southern Region's Class 73 electro-diesel locomotives also found work on these weekend infrastructure traffic duties. Class member No. 73108 was one of these to carry the yellow and grey Departmental livery and a regular visitor to both the stabling point at Eastleigh and, a little further north, at the Civil Engineers yard at Woking.

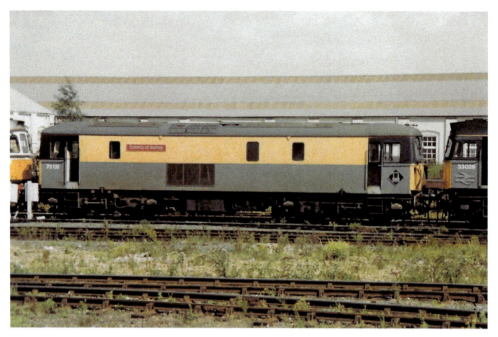

Another 'Dutch'-liveried example of the Class 73s, No. 73131 *County of Surrey*, is seen on the stabling point at Eastleigh in August 1992. On this occasion, the Class 73 is stabled between a pair of Crompton Class 33 diesels.

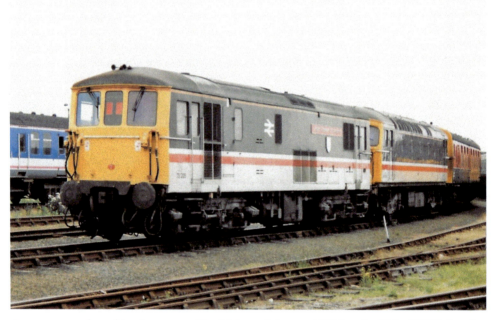

A more unusual combination seen at Eastleigh on 5 August 1991 involved No. 73205 *London Chamber of Commerce* and No. 83301. The latter loco was a renumbering for No. 33115, which had been fitted with experimental bogies. This pair of locos was being used in the testing of the bogies and electric current collection for the soon to be introduced Eurostar Passenger Services.

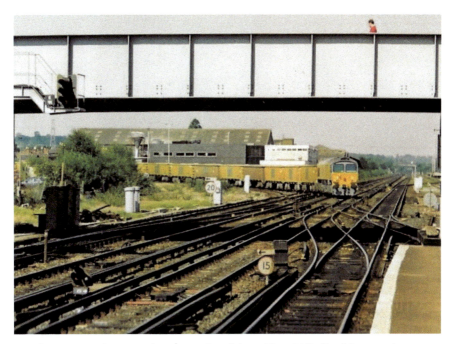

Freight operator ARC Southern introduced four Class 59/1 diesel locomotives on to their stone workings from 1990 onwards. A year after introduction, No. 59102 comes off the curve of the Chandler's Ford line and approaches Eastleigh station on a loaded stone working on 31 August 1991.

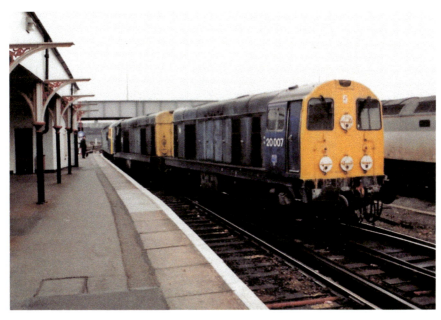

A rare working in February 1992 saw a pair of 'English Electric Type 1' Class 20 diesel locos, Nos 20007 and 20032, visit Eastleigh. They worked a Solent and Wessex Wanderer rail tour between here and Weymouth. The duo is seen waiting in the station area, with No. 56020 for company.

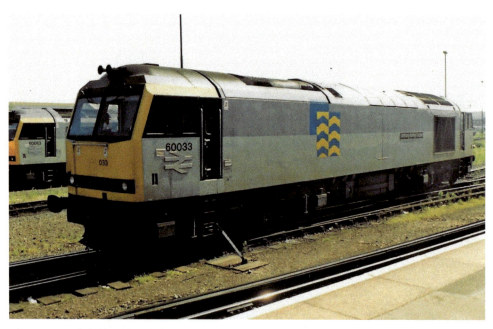

The 100 Brush-built Class 60 locomotives appeared at the end of the days of our nationalised railway, before all these locomotives passed into the private ownership of English, Welsh and Scottish Railways (EWS). They were designed to displace many of the older machines, including a number of the other classes featured here. In August 1991, the stabling point was home to No. 60033 *Anthony Ashley Cooper*, with sister loco No. 60063 *James Murray* in the background.

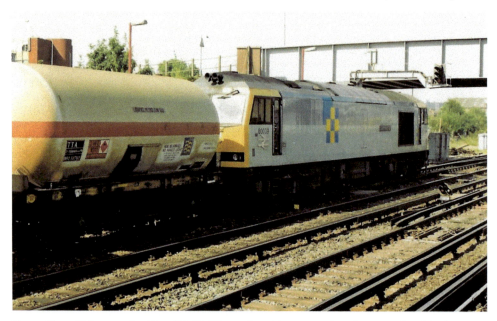

Sister Class 60 locomotive No. 60039 *Glastonbury Tor* was only a few months old when seen at Eastleigh in the summer of 1991. In those days, Railfreight was split into several divisions. Despite the loco carrying the decals of Railfreight Construction, it is heading a Fawley working for Railfreight's Petroleum sector.

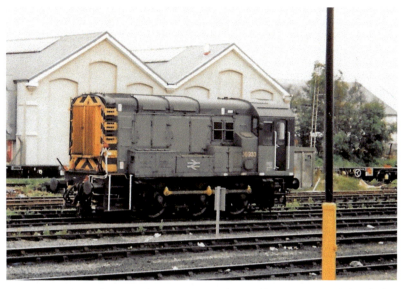

In British Rail days, shunting duties were performed by a variety of diesel shunter classes, including the ubiquitous Class 08, of which almost 1,000 were built from the early 1950s onwards. Eastleigh was home to a large allocation of these shunting engines, including No. 08933. This Eastleigh shunter was built at Darlington Works in 1962 and is seen stabled some thirty years later, carrying a plain grey departmental livery.

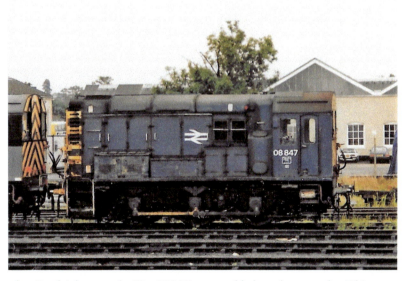

Another Eastleigh example, No. 08847, was stabled on the same day. This example was built at Horwich works in 1961 and remains in use to the present day. With recent spells at Greater Anglia's depots in East Anglia and a period at the Mid Norfolk Railway at Dereham, it has been noted more recently shunting at P.D. Ports on Teesside. This loco is a good example of the versatility and endurance of these veteran machines.

Eastleigh – Freightliner Services

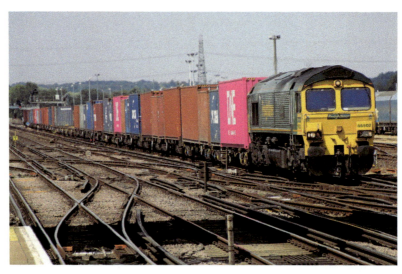

In the early to mid-1990s the carrying of freight on Britain's railways moved from that of a nationalised network to one primarily in the hands of a few private operators. The container traffic to and from Southampton Docks was to pass into the ownership of Freightliner Ltd, a newly formed company that was a result of a management buyout from British Rail. On 14 August 2018, their Class 66 loco, No. 66502, heads for the docks with a container train from the terminal at Garston on Merseyside.

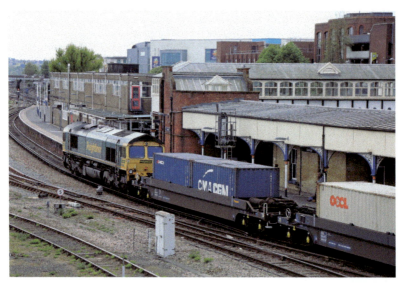

These Freightliner services operate between Southampton and a variety of destinations across the UK. On 29 April 2017, No. 66548 pauses in Eastleigh station platform on a working from the terminal at Leeds. The Tiphook 'pocket' wagons seen at the front of this train enable the taller, 9-feet 6-inch shipping containers to be carried on these Freightliner services.

Eastleigh – Freightliner Services

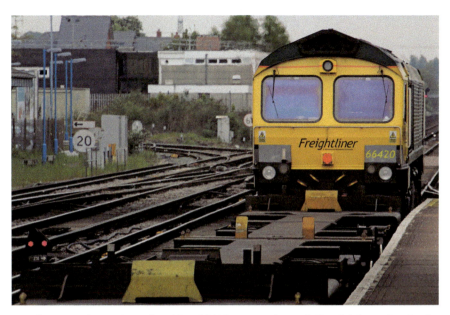

On the same day, a Saturday, No. 66420 passes through Eastleigh station in the opposite direction, on a rake of empty flat wagons. Later in this publication we will take a more detailed look at Freightliner's Maritime hub on the western side of Southampton. Stabling space there is limited at weekends when the nearby docks are closed. This rake of wagons will therefore be stabled for the weekend in the nearby Eastleigh East Yard.

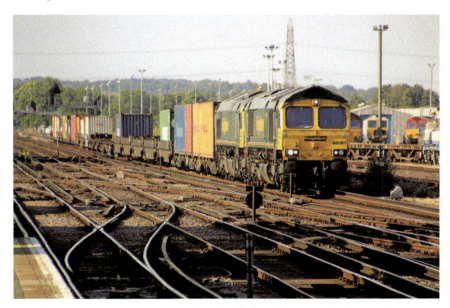

Freightliner's container trains are often double headed, particularly in order to move locos between their various UK depots and yards. In this 2018 view, No. 66587 is seen passing Eastleigh East Yard heading to Southampton Maritime. Sister loco No. 66551 is seen 'dead in train' (being hauled as part of the train's consist, but not providing motive power).

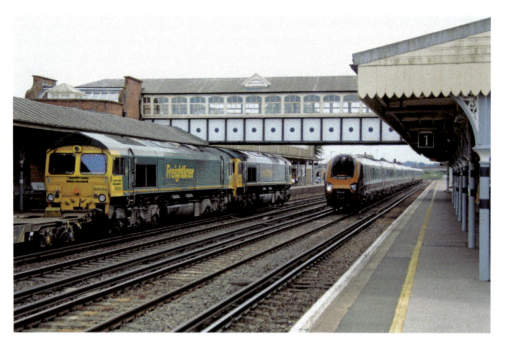

On 26 June 2021, another pairing, Nos 66513 and 66566, are seen pausing in Eastleigh platform to enable a crew change there. Meanwhile, Voyager No. 221119 is about to pass them on the Up main line on a northbound CrossCountry passenger service to Manchester Piccadilly.

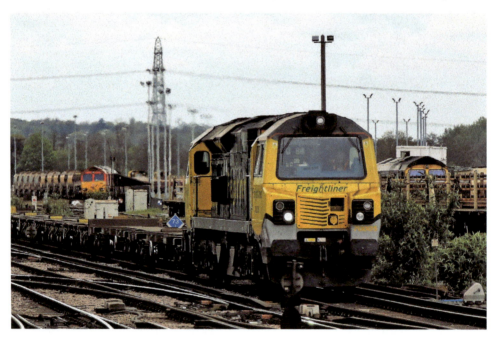

Freightliner operates a small fleet of Class 70 locomotives to complement the extensive pool of Class 66 locomotives on its books. These Class 70 duties often include hauling container trains, such as No. 70005, seen here approaching Eastleigh in 2017 as it heads for the terminal at Maritime.

Eastleigh – Freightliner Services

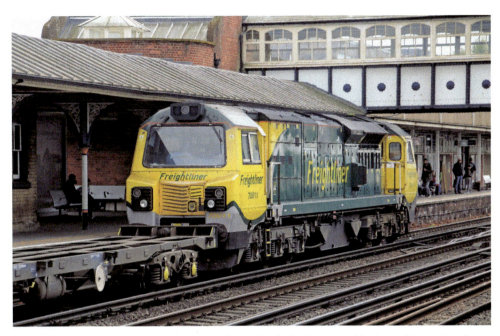

The pool of nineteen Class 70 Freightliner locos has had a history of highs and lows since being introduced from 2009. Many examples have spent lengthy periods stored out of use at the company's depot at Balm Road in Leeds. In recent years, their container duties are primarily centred on the docks at Southampton rather than Felixstowe. Another Class 70 example, No. 70011, pauses in Eastleigh station for a crew change before returning its wagons to Southampton Maritime. This 2017 working had originated at Freightliner's yard at Basford Hall, Crewe.

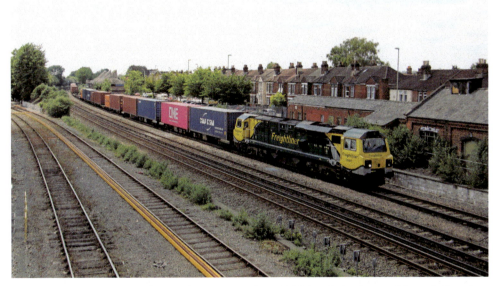

On 23 June 2021, sister Class 70 locomotive No. 70007 heads in the northbound direction, having just left Southampton Maritime terminal. It is seen approaching Eastleigh station with a fully loaded container train.

Eastleigh – DB Cargo Services

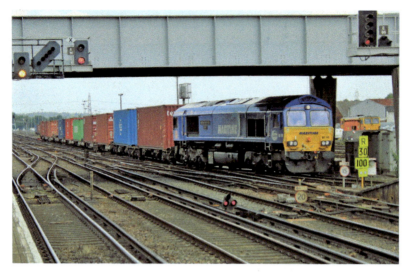

Rival operator English, Welsh & Scottish Railways (EWS) emerged as the largest freight operator under the newly privatised railways of the 1990s. The company were to see several rebrandings and changes of ownership before becoming DB Cargo, as they are known today. Their Class 66 loco, No. 66148, emerges from Eastleigh East Yard and heads for Southampton Docks on a 2021 working from Wakefield Euro Terminal in West Yorkshire.

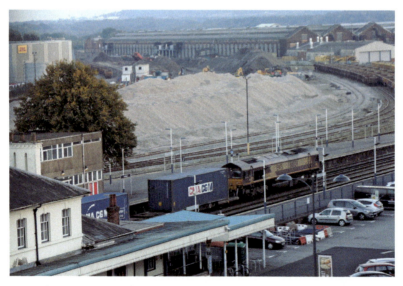

On 3 October 2015, sister loco No. 66024 is also seen heading for Southampton Docks as it passes through Eastleigh on the Down main line. The extent of Eastleigh's virtual quarry can clearly be seen beyond this train. This ballast pile accounts for numerous infrastructure workings in the area, particularly overnight and at weekends, with DB Cargo among the main beneficiaries.

Eastleigh – DB Cargo Services

When this view was taken on 15 July 2014, DB Cargo were responsible for shunting these infrastructure wagon rakes in and around Eastleigh's yards. That day these duties were in the hands of their Class 60 loco No. 60045 *The Permanent Way Institution*.

The height of the virtual quarry's ballast pile can again be seen in this view of DB Cargo Class 66 locomotive No. 66136. It is seen the following day waiting for its rake of wagons to be loaded at the quarry.

These infrastructure duties extend across much of southern England. On 29 April 2017, for example, No. 66114 is seen leaving Eastleigh Yard with a loaded ballast train. It is heading for a weekend engineering possession near Horsham, West Sussex.

To satisfy these infrastructure obligations, on Saturdays DB Cargo regularly despatched locos to Eastleigh to haul these engineering trains. In this view of Eastleigh's East Yard on 29 April 2017, a four-loco Class 66 convoy has just arrived on a light engine move from Margam, in South Wales, which also picked up loco(s) at Westbury. The convoy consisted of Nos 66034, 66002, 66004 and 66093.

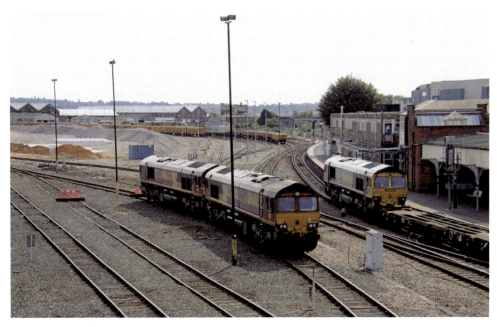

The strategic location of the virtual quarry and its sidings is evident in this view to the east of Eastleigh station platforms, taken on 11 September 2020. DB Cargo's Nos 66089 and 66092 are stabled with the ballast pile behind. Meanwhile, Freightliner's No. 66563 passes on its way to Southampton Maritime, with a container working from Freightliner's yards at Basford Hall, Crewe.

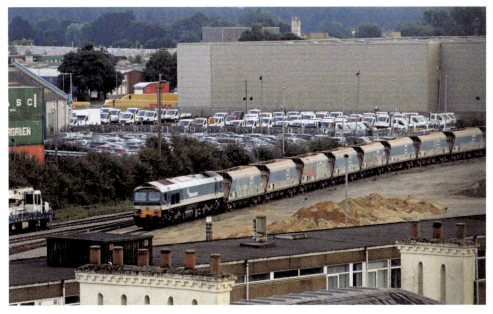

In 2018, DB Cargo were also responsible for Southampton area stone workings to and from the major West of England quarries at Whatley and Merehead, in the Mendip Hills. On 13 July that year, No. 59103 *Village of Mells* is about to leave Eastleigh and return a rake of empty stone wagons to the quarry at Merehead.

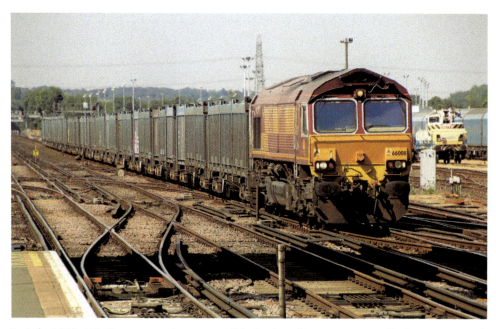

In July 2018, DB Cargo was also responsible for handling gypsum traffic between British Gypsum's plant at Mountfield, Kent, and the docks at Southampton. On this occasion Class 66 loco No. 66008 is in charge of the train. This loco was shortly to be sent on extended hire to Direct Rail Services, while the British Gypsum contract itself was soon to be awarded to GB Railfreight.

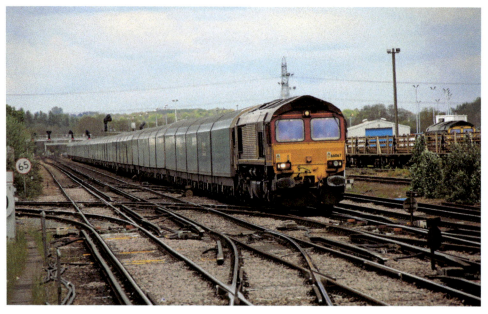

DB Cargo also handle substantial volumes of newly built cars to Southampton Docks for loading and export. On 29 April 2017, No. 66067 passes Eastleigh Yard on one of these workings. On this occasion the car transporters were from Morris Cowley, Oxford, conveying Minis to the docks at Southampton.

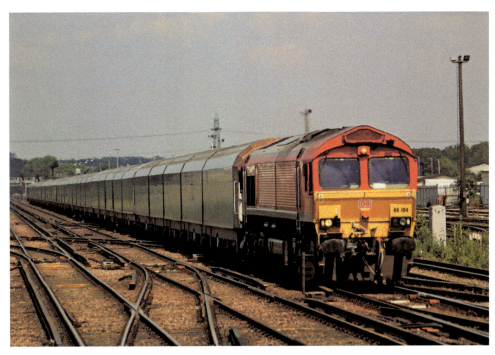

On 23 June 2021, the same working is in the hands of sister Class 66 locomotive No. 66104. The docks at Southampton handle close to a million vehicles on an annual basis, with DB Cargo responsible for this railborne traffic.

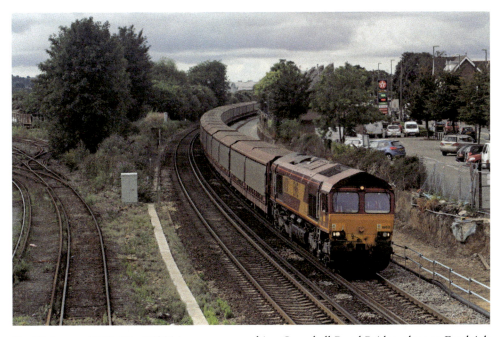

On 30 August 2013, No. 66031 is seen approaching Campbell Road Bridge, close to Eastleigh station. This empty northbound working is returning a lengthy rake of cartics to Jaguar Land Rover (JLR) at Halewood on Merseyside, for reloading.

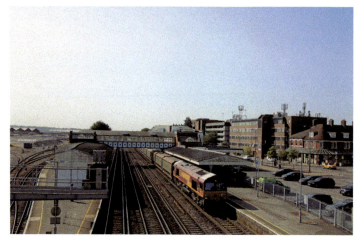

Another rake of empty cartics, hauled by DB Cargo's No. 66177, pauses briefly in Eastleigh station platform before heading north. The journey between Southampton and Merseyside takes around six hours.

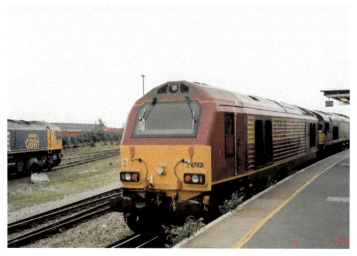

Eastleigh has also seen occasional visits by DB Cargo Class 67 locos. On 31 July 2008, No. 67021 arrives in the station platform behind a Class 66, before being shunted into the nearby East Yard.

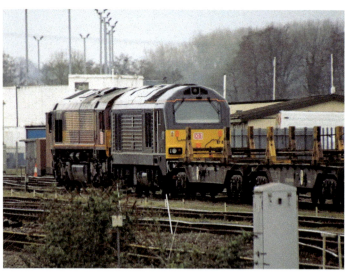

Royal-liveried visitor No. 67005 *Queen's Messenger* is another Class 67 visitor to East Yard on 19 March 2019. It, too, is seen behind a DB Cargo Class 66. On this occasion the Class 67 loco is dead in train.

Eastleigh – DB Cargo Services

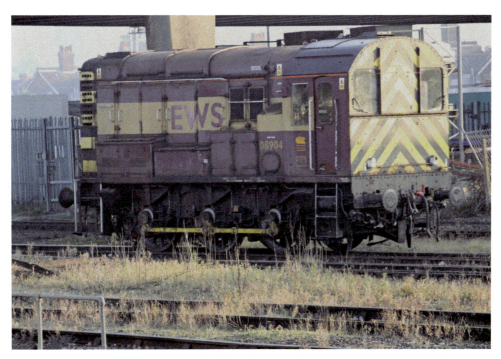

With DB Cargo, or EWS as it was until rebranding in early 2016, occupying East Yard in 2015, there was still a place for the Class 08 diesel shunters to shunt the area. On 3 October that year, No. 08904 is awaiting its next duty.

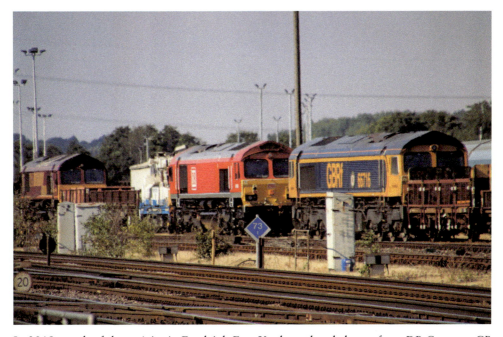

In 2019, much of the activity in Eastleigh East Yard was handed over from DB Cargo to GB Railfreight. In a scene from July 2018, this was a hint of things to come. In this view, DB Cargo's Nos 66050 and 66206 are joined by GBRf's No. 66716.

Eastleigh – GB Railfreight (GBRf) Services

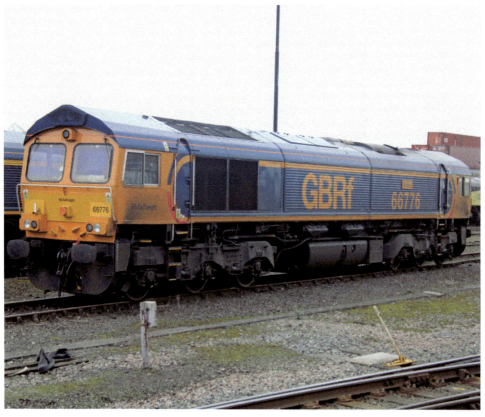

Britain's third largest rail freight operator, GBRf, came into existence several years after rail privatisation, therefore inheriting neither locos nor rolling stock from the BR sell-off. Instead, it has progressively added Class 66 locos to its fleet, including No. 66776 *Joanne*, seen here on the stabling point on 23 March 2019.

Eastleigh – GB Railfreight (GBRf) Services 45

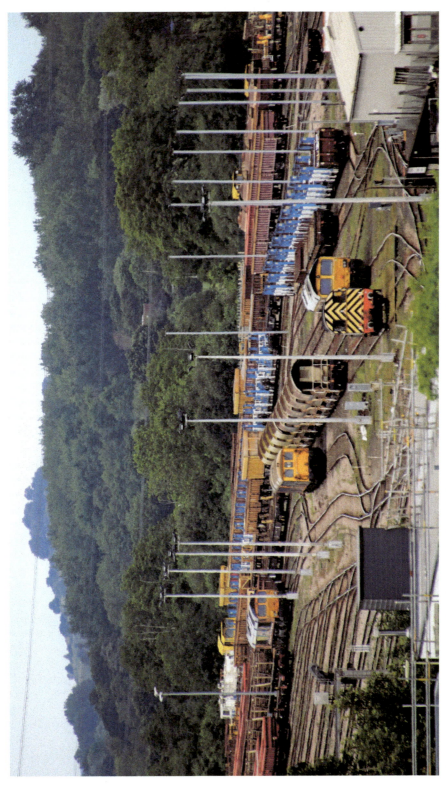

This is the view of Eastleigh's East Yard on 26 June 2021, with the new occupancy by GB Railfreight clearly in evidence. That afternoon, the yard is occupied by a variety of their motive power, with, from left to right, No. 66720, No. 73141 *Charlotte*, No. 73201 *Broadlands*, No. 66703 *Colchester PSB 1981 – 2002* and No. 08511.

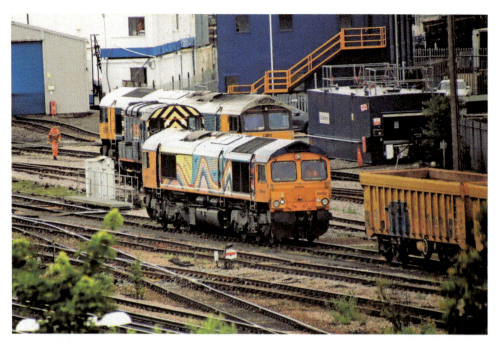

Two days later, one of the yard occupants in the previous photo is about to take up its next duty. GBRf's Class 66 No. 66720 is reversing on to a rake of empty box wagons and will head to the Leicestershire quarry at Mountsorrel for loading and return in order to replenish the aggregate stockpile at Eastleigh's virtual quarry.

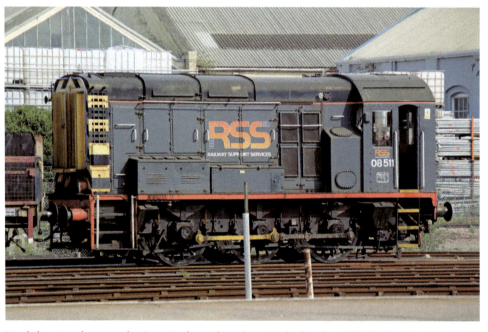

Yard shunting duties in the East Yard area have been in the hands of GB Railfreight since 2019. On 11 September 2020, Railway Support Services' Class 08 No. 08511 was one of the two shunters on hire to GBRf for these duties.

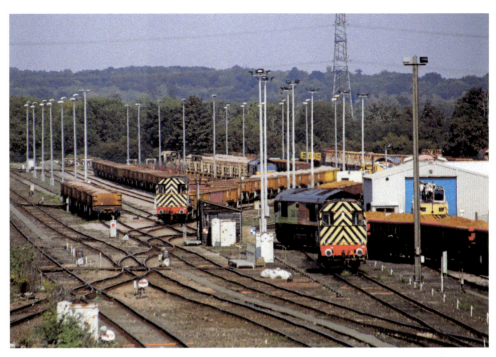

A week later, No. 08511 is seen working in the yard, together with No. 08460, which was out of action that day. Colas Rail's No. 66849 *Wylam Dilly* completes the yard's trio of occupants that afternoon.

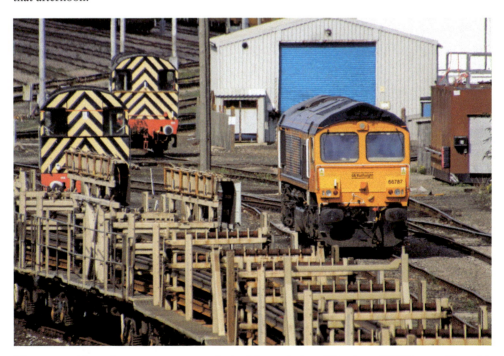

The two resident shunters are seen again in this yard view. This time, GBRf's own Class 66, No. 66787, is also seen stabled between duties.

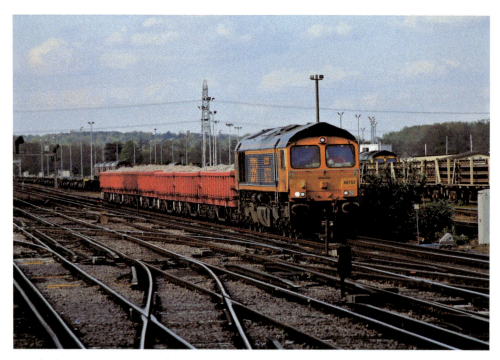

On the last weekend in April 2017, GB Railfreight were participants in a Network Rail engineering possession in West Sussex. On Saturday 29 April, No.66753 *EMD Roberts Road* is leaving Eastleigh's East Yard with a loaded ballast working to Horsham.

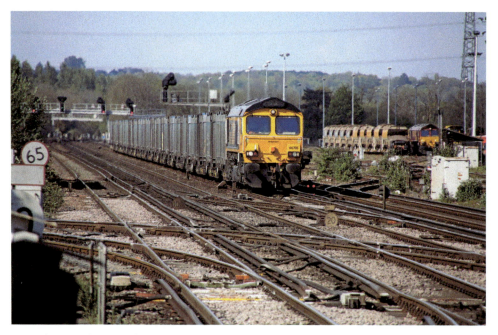

Later the same day, sister loco No. 66706 *Nene Valley* passes the yard and heads for Southampton Docks, with a rake of gypsum from Mountfield, Kent. By 2017, GB Railfreight had taken over these workings from DB Cargo.

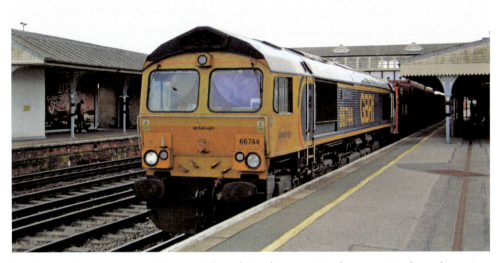

GBRf have also commenced intermodal workings between Southampton Docks and a variety of UK container terminals, offering competition to rivals, Freightliner and DB Cargo in this intermodal marketplace. On 23 June 2021, No. 66744 *Crossrail* pauses in the station platform before heading north to the inland terminal at East Midlands Gateway.

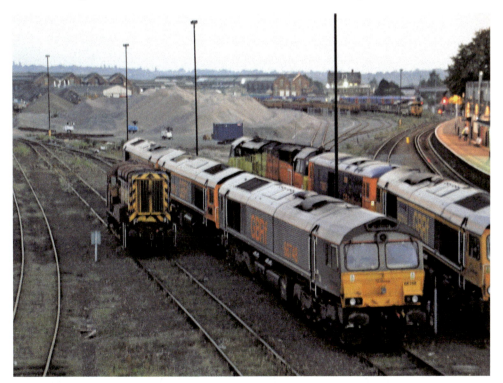

As night falls on 3 October 2015, GBRf locos are the main occupants of Eastleigh stabling point. Their Class 66 locomotive No. 66748 is in the foreground.

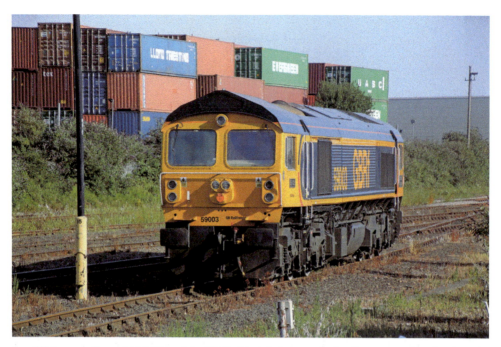

In addition to a fleet of 100 Class 66s, GB Railfreight have a single Class 59 on their books. The loco, No. 59003 *Yeoman Highlander,* was to spend from 1997 to 2014 working in Germany. In October 2014, GBRf returned the loco to the UK and it is regularly seen in the Eastleigh area. To the author's delight, its *Yeoman Highlander* nameplates, fitted by Foster Yeoman back in 1986, have been retained.

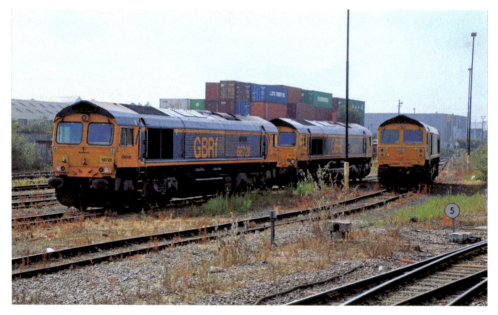

On 14 July 2018, the Class 59 was to be found on the stabling point. Its fellow occupants that day were Class 66 locomotives No. 66728 *Institution of Railway Operators* and No. 66716 *Locomotive & Carriage Institution Centenary 1911 – 2011.*

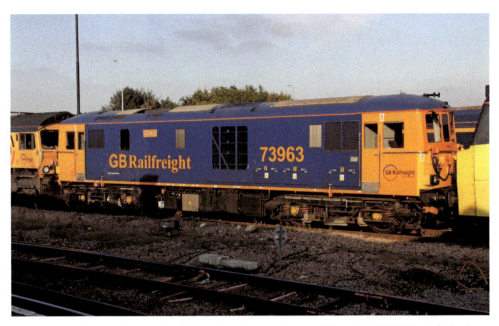

The veteran Class 73 electro-diesels have found a new lease of life with GBRf. Their duties have included Network Rail test trains between Derby and routes in the south of England, usually operated with a pair of locos from a small pool of Class 73/9 machines, working in top'n'tail mode. In October 2015, one of these machines, No. 73963 *Janice*, was stabled at Eastleigh.

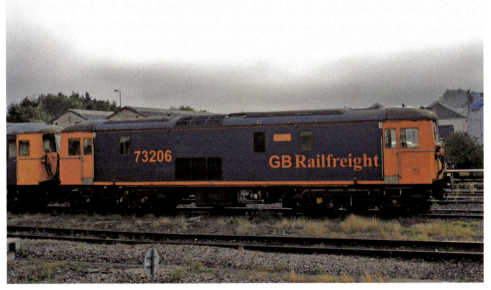

The remainder of the GBRf Class 73 fleet are often found at former Southern Region locations in Kent and Sussex such as Tonbridge, St Leonards and Hoo Junction. They are also regular visitors to the South Western Main Line at both Woking and Eastleigh. On 30 August 2013, No. 73206 *Lisa* is seen on the latter's stabling point. This loco was formerly used on Gatwick Express services and has since been converted to Class 73/9, 73963 and now named *Janice*, as seen in the previous photo.

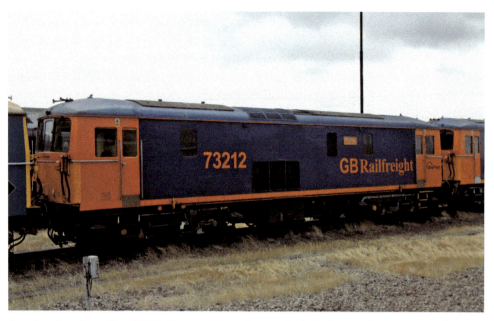

Another sister loco, No. 73212 *Fiona*, is also a former Gatwick Express loco. On 14 July 2014, it was to be found stabled at Eastleigh. These Class 73 locos have notched up over half a century in service.

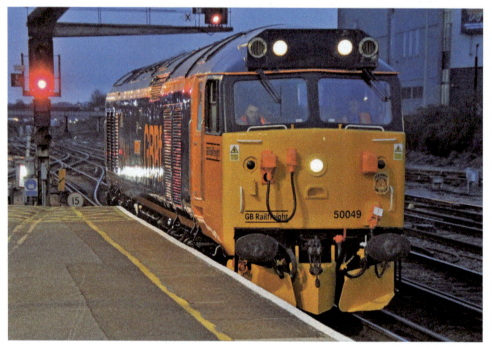

Two more veteran machines, both also over fifty years old, have recently been taken under GBRf's wing. This includes being outshopped with full corporate livery. On 20 March 2019, Class 50 No. 50049 *Defiance* has just left the works and is about to go light engine to Romsey and back.

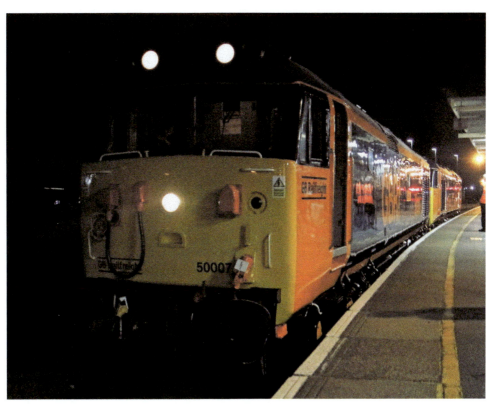

Sister loco No. 50007 *Hercules* was then coupled to No. 50049 *Defiance* on its return, for the duo to leave on a light engine run north on the South Western Main Line towards London, in readiness for a charter train working the next day.

Eastleigh – Colas Rail Services

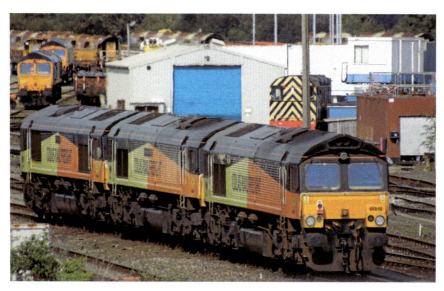

Colas Rail also operates a small fleet of five Class 66 locomotives. These machines often divide their time between the southern infrastructure hubs of Hoo Junction, in Kent, and Eastleigh. On 11 September 2020, three of these locos, No. 66849 *Wylam Dilly*, No. 66850 *David Maidment OBE* and No. 66846, are waiting to leave Eastleigh Yard and work light engines to Hoo Junction.

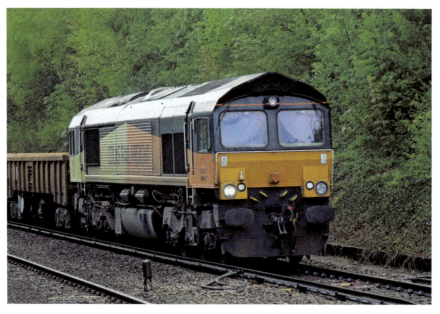

A single Class 66, No. 66847, is in charge of a working in the opposite direction on 1 May 2017. It is seen passing Shawford, between Winchester and Eastleigh, on a working from Hoo Junction to Eastleigh East Yard.

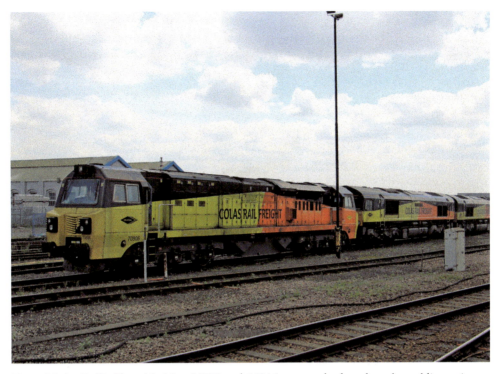

Two of Colas Rail's Class 66s, Nos 66850 and 66846, were to be found on the stabling point on 23 June 2020. They were keeping company with Class 70 locomotive No. 70806. Colas Rail's operates a fleet of seventeen of these Class 70 locomotives.

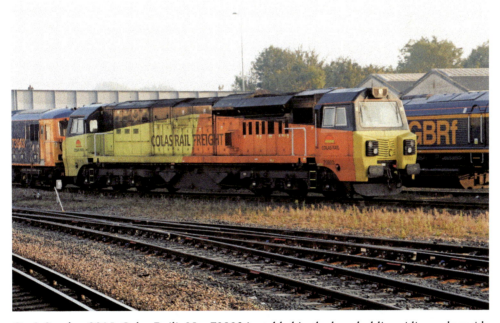

On 3 October 2015, Colas Rail's No. 70803 is stabled in the loco holding sidings, alongside Class 66 and Class 73 examples of the GBRf fleet.

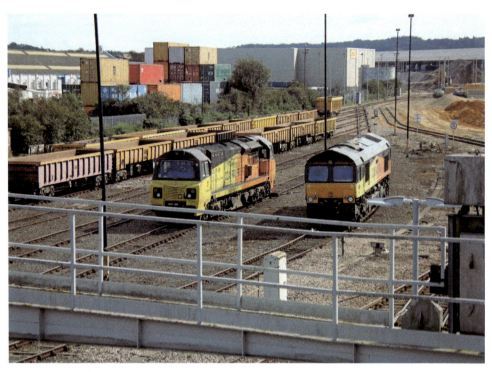

It was a quiet day in the holding sidings on 12 September 2020. Just two Colas Rail locos, Nos 70811 and 66847, were stabled side by side between duties.

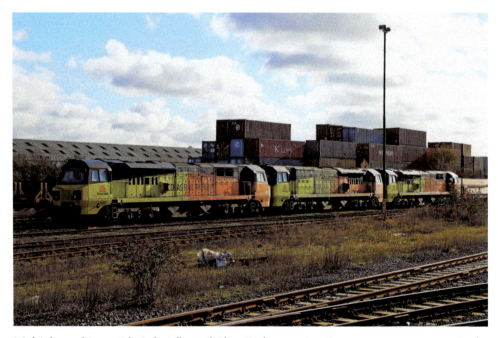

Multiple workings with Colas' fleet of Class 70 locomotives is a common occurrence in the Eastleigh area. On 28 November 2017, Nos 70807, 70808 and 70810 are ready to depart in a light engine convoy.

Eastleigh – Colas Rail Services

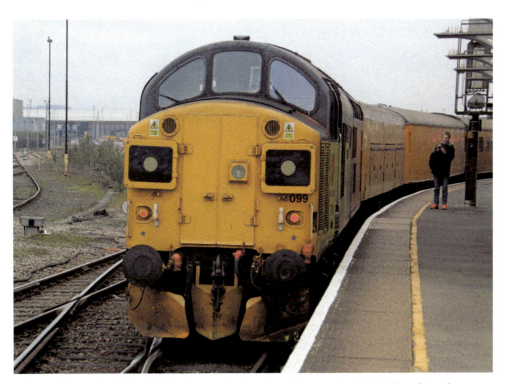

Colas Rail's veteran fleet of Class 37s are also regular visitors to the Eastleigh and Southampton area, particularly in charge of Network Rail test trains. On 20 March 2019, No. 37099 *Merl Evans 1947 – 2016* has just arrived in the station platform. This 'English Electric Type 3' locomotive was built back in 1962.

Eastleigh – Other Operators' Services

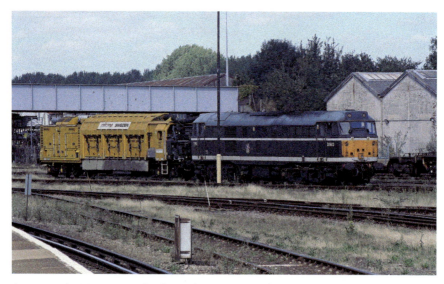

An unusual visitor to Eastleigh Yard in August 2013 was Class 31 loco No. 31190. The Brush Type 2 diesel, operated by DC Rail, had arrived delivering a Railvac, numbered 7095150014, to the yard.

A more recent DC Rail working has seen their small fleet of Class 60 locomotives deliver ballast to Eastleigh. On 18 September 2020, No. 60055 *Thomas Barnardo* has just uncoupled from its rake of box wagons and will stable in East Yard until the wagons are unloaded.

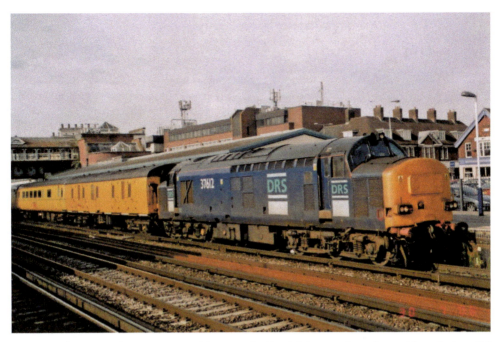

Direct Rail Services' locos are rare visitors to the Eastleigh area these days, although they did regularly operate Network Rail test trains for many years. Back in July 2008, for example, their Class 37 loco No. 37612 stops in Eastleigh station while operating a test train about to return north to Derby.

A variety of track machines also make visits to the Eastleigh area. On 23 June 2021, for example, Plasser & Theurer tamper No. DR73938 is about to head south through Eastleigh station.

Eastleigh Arlington

The town of Eastleigh has a long association with railways, with the first carriage works being built there back in 1891. Following Grouping in 1923, Eastleigh became the chief works for the Southern Railway. Later, after rail privatisation in the mid-1990s, it had a new lease of life following a management buyout. One of the works' residents, shunter No. 07007, has a long association with the area, starting life as No. D2991 in 1962 as a shunting loco in the Southampton Docks area.

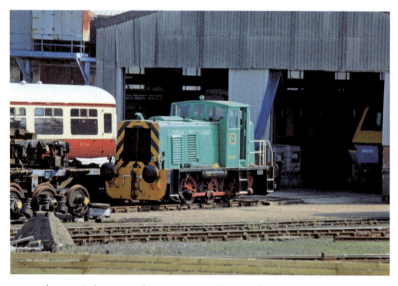

Known today as Arlington Fleet Services, the workshops see a wide variety of visitors as evidenced in the selection of photos that follow. Another of its longer-term residents is Ruston & Hornby's shunter No. 01508, built in 1961, which now sports Arlington's own green livery. It is seen in the works yard on 16 September 2020.

Arlington's No. 08567 is an even older diesel shunter, having been built in 1959 as No. D3734 at Crewe Works. The former DB Cargo shunter was put up for sale in 2015 and acquired by Arlington Fleet Services. It still sports a faded EWS livery.

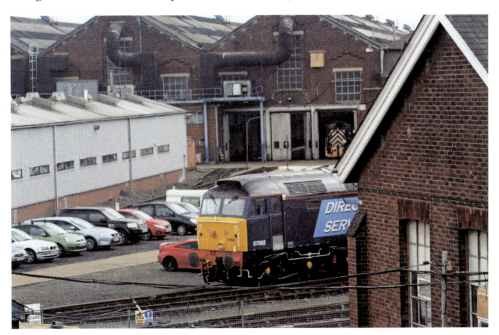

Campbell Road is situated a few hundred yards south of Eastleigh station and offers glimpses into the Arlington complex. This is a typical view, taken in 2013, showing a glimpse of Direct Rail Services' (DRS) No. 57002 together with another view of Class 07 shunter No. 07007.

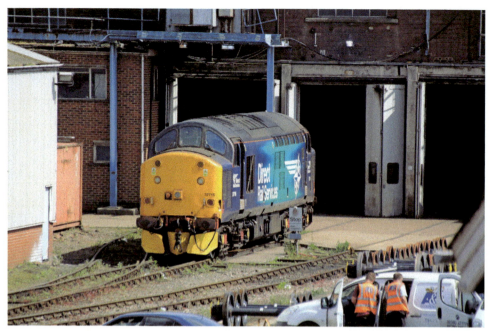

Another DRS loco, No. 37716, is seen at the works on 13 May 2022. Although no longer in regular revenue-earning use, the loco had been a regular performer on loco-hauled passenger services in East Anglia three or four years earlier.

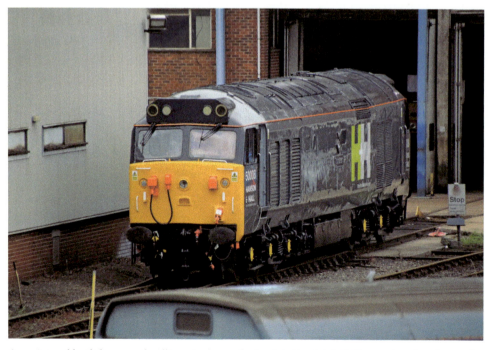

A variety of both locos and rolling stock regularly visit Eastleigh Arlington's paint shops. On 19 June 2019, for example, Hanson & Hall's Class 50 No. 50008 *Thunderer* has emerged in their distinctive grey colour scheme.

Eastleigh Arlington

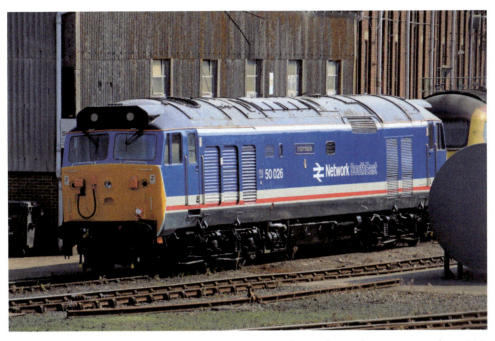

Another Class 50, No. 50026 *Indomitable*, is seen in the works yard on 16 September 2020. Its Network SouthEast (NSE) livery evokes memories of the class regularly performing on passenger duties from London Waterloo to the West of England, during NSE's custodianship of the services to Salisbury, Yeovil and Exeter.

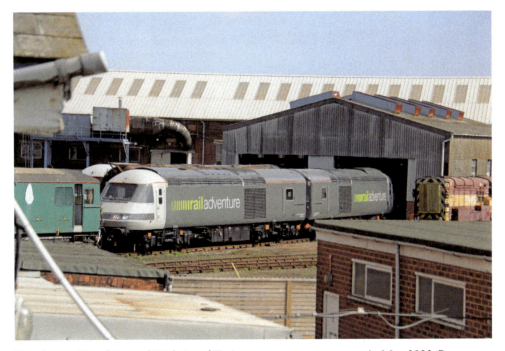

Two former Grand Central High Speed Train power cars were present in May 2022. Power cars Nos 43480 and 43484 had just been repainted in Rail Adventure colours.

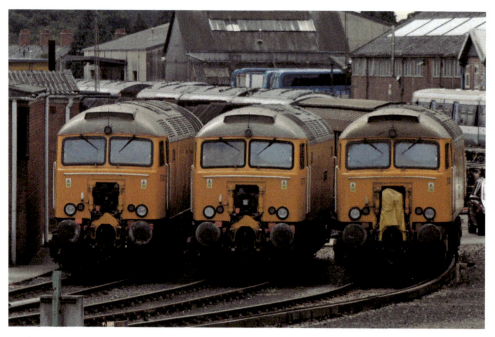

Back in 2013, Arlington was home to three Network Rail yellow-liveried Class 57 locos. Nos 57301, 57312 and 57305 are seen in this view. Eastleigh was the base for these Network Rail locos at the time.

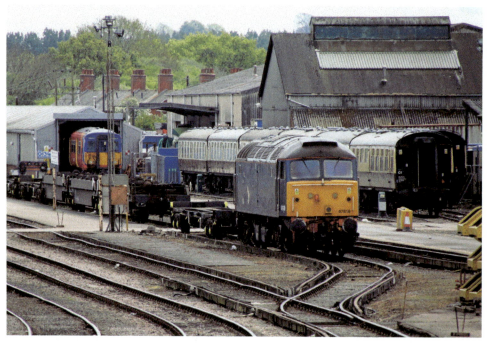

This is the view of the works yard taken from a little further down Campbell Road. On 29 April 2017, the yard is home to a variety of rolling stock with Class 47 locomotive No. 47818 in the centre.

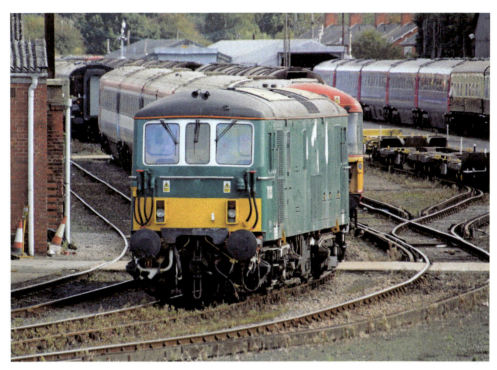

Class 73 No. 73133 is another long-term occupant of the yard. This green machine had been the depot shunter at nearby Bournemouth for several years before being moved to Eastleigh in 2017.

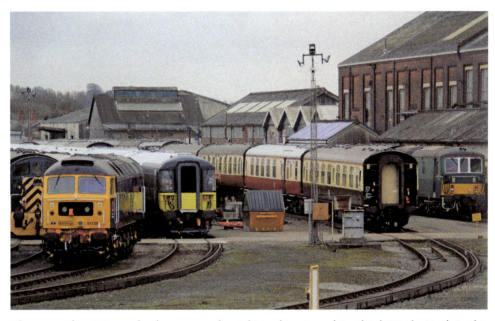

The same Class 73 can also be seen on the right in this view of Eastleigh Works Yard. In this photo, taken in March 2019, GB Railfreight's No. 47739 *Robin of Templecombe* is on the left, with No. 07007 again partially visible, together with an unidentified Class 442 electric multiple unit.

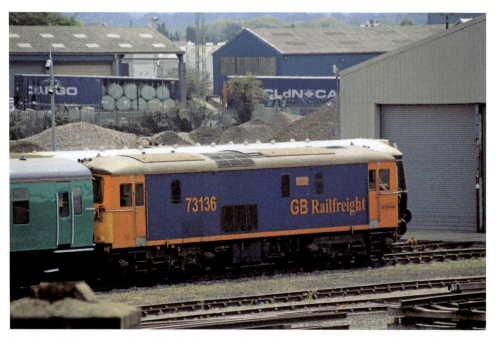

Another GBRf veteran, No. 73136 *Mhairi*, built in 1965, was to be found in the works yard on 14 July 2018. The loco had been there around a month at the time, although the reason for its visit is unknown.

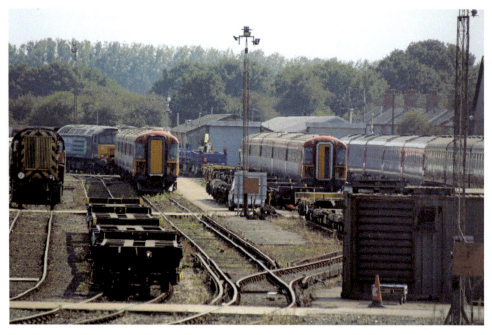

The British Rail Class 442 'Wessex Electrics' were introduced to the SWML on the completion of the electrification from London Waterloo to Weymouth in 1988. Thirty years later, however, the Covid pandemic signalled an early, and perhaps premature, retirement for the fleet in 2020. In September that year, two of these units languished in the works yard.

Another class to see its demise around the same time was the fleet of Class 142 diesel multiple units, often referred to as 'Pacers'. Since then, a number of these units have been donated to railway preservation groups and other worthy causes. Two examples of the Pacer fleet most recently in use with Northern, Nos 142032 and 142089, were in the works yard, on the same day in September 2020.

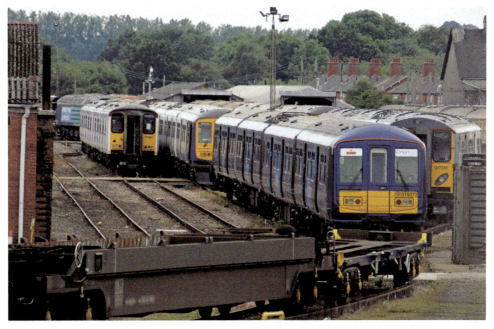

Arlington Fleet Services offers storage services for a variety of rolling stock, taking advantage of the extensive sidings at its disposal. On 19 June 2021, electric multiple units Nos 317662, 319373 and 317722 are among the rolling stock being housed here.

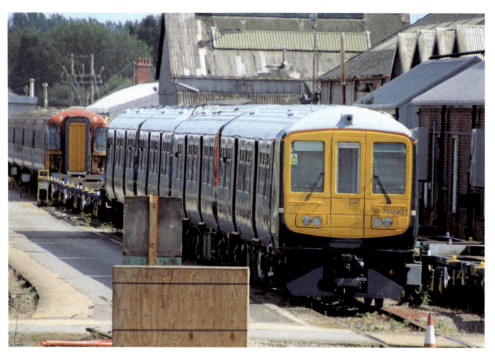

The Class 769 bi-mode and tri-mode units, converted from former Class 319 units, also visit Eastleigh Arlington. On 13 May 2022, No. 769937, formerly No. 319437, was stabled in the works yard. It would be moved to Long Marston later that month.

This photo demonstrates that just about any type of rolling stock can appear at Arlington. Back in July 2018, for example, former Western Region first generation diesel multiple unit car No. 51346 was awaiting scrapping.

Southampton – Around the City and Suburbs

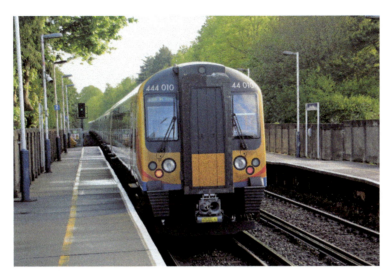

We commence our look at the railways of Southampton city and suburbs at Shawford, to the north of Eastleigh. Shawford is the only station between Eastleigh and Winchester. It is served by South Western Railway's stopping services between Winchester and Bournemouth, as well as some London Waterloo services. On 1 May 2017, No. 444010 is seen leaving Shawford station.

2 miles to the north-west of Eastleigh lies Chandler's Ford. The station, on the non-electrified branch line from Eastleigh to Romsey, was originally closed in 1969. It was subsequently reopened in October 2003. The original two-platform station can be seen in this 2017 view. Only a single, bi-directional platform has been used since the station's reopening.

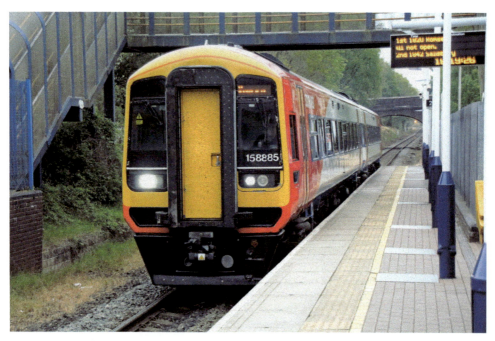

The lack of third rail electrification on the branch means that two-car Class 158 diesel units, based at Salisbury, usually operate the passenger service linking Romsey and Salisbury with a circular routing via Southampton Central. On 30 April 2017, No. 158885 is forming one of these hourly stopping services.

These passenger trains join the South Western Main Line via a tight curve just to the north of Eastleigh station. On 20 March 2019, it's the turn of unit No. 158886 to be used on this Southampton-bound service.

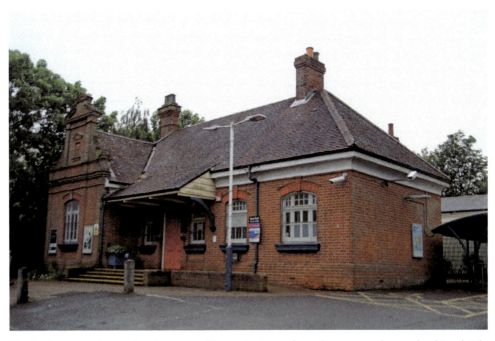

The Parkway station at Southampton Airport is situated a mile or so to the south of Eastleigh, adjacent to the airport's terminal buildings, with the station at Swaythling located another mile or so beyond. This view shows Swaythling's grandiose Victorian station building, which is Grade II listed and dates from the 1880s.

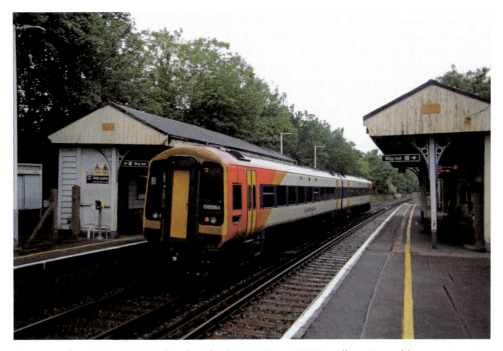

On a wet day in June 2021, diesel multiple unit No. 158884 calls at Swaythling station on a northbound SWR service from Salisbury to Romsey.

At St Denys, the main line from London Waterloo to Bournemouth and Weymouth is joined by the coastway line from Portsmouth to Southampton. This June 2021 view shows the four platform station, with the London lines on the left and the Portsmouth lines to the right.

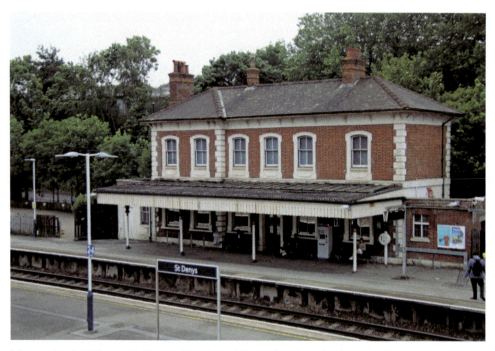

The station building at St Denys, like Swaythling, also dates back to the Victorian era, being constructed in the 1860s. This Grade II listed building is now in private ownership.

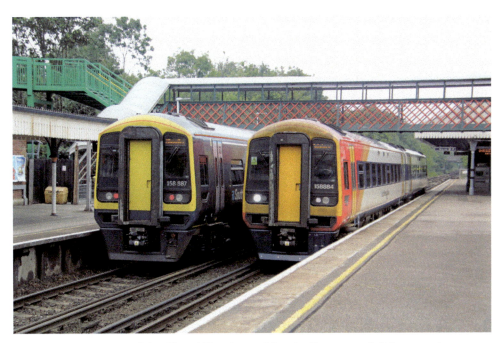

On 27 June 2021, two of the Class 158 units working the Romsey to Salisbury service meet at St Denys. Unit No. 158887 is heading for Romsey, while No. 158884 is heading to Southampton and Salisbury.

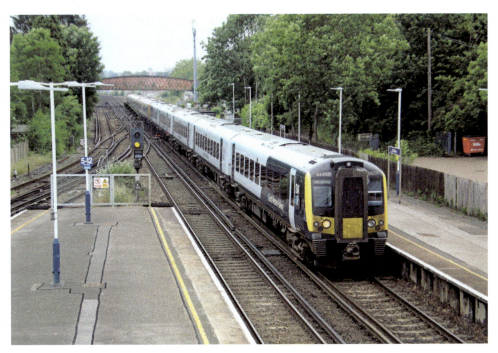

A few minutes later that day, a pair of Class 444 electric multiple units, Nos 444008 and 444022, are passing through St Denys station on a non-stop service from Weymouth to London Waterloo.

To the south of St Denys station is the Traincare Facility at Northam, adjacent to the Southampton-bound running lines. The depot was opened in 2003 and was the first depot to be purpose-built for rolling stock manufacturer, Siemens, in order to maintain the fleet of Class 444 and Class 450 electric units.

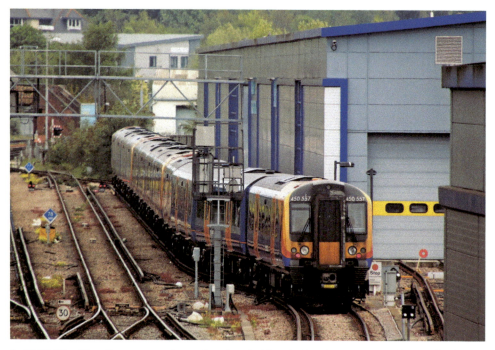

In 2017, The First Group were the major shareholders in South Western Railway, which took over these services from Stagecoach in 2017. On 30 April that year, Class 450 unit No. 450557 is seen stabled alongside the main depot building, adjacent to the South Western Main Line.

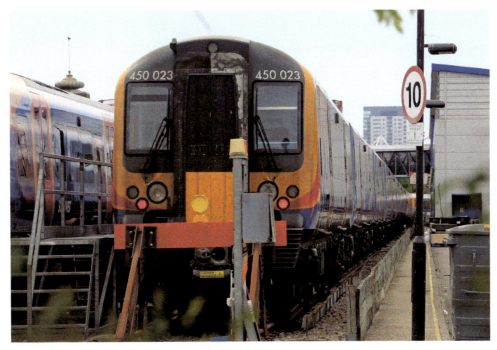

Viewed from the opposite (northern) end of the Siemens complex, sister unit No. 450023 is stabled at the rear of the depot area on the same day.

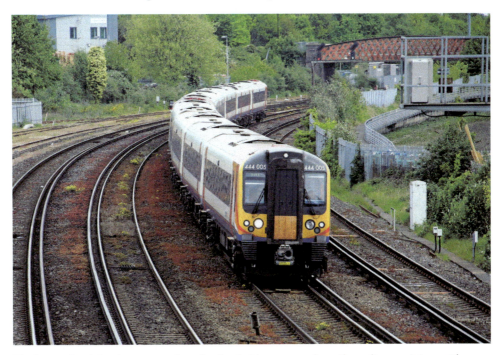

To the north of the depot complex, the footbridge across the railway lines at Mount Pleasant Road level crossing offers good views of trains passing through the Northam area. In 2017, No. 444005 is seen approaching the level crossing, leading on a ten-car SWR service.

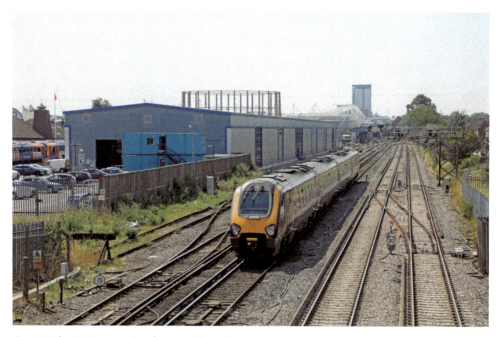

On 14 July 2018, a passing four-car CrossCountry Voyager, No. 220001, is seen from the same footbridge, as it runs alongside the Siemens depot complex.

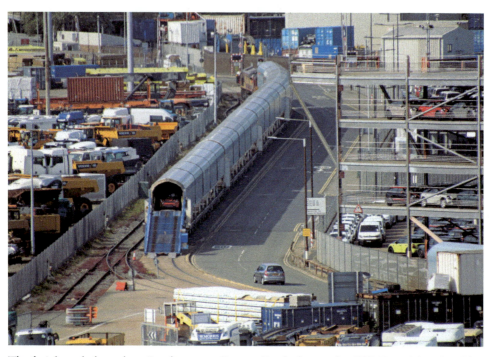

The freight-only branch to Southampton Eastern Docks leaves the SWML at this point. This is the destination for the DB Cargo freight services, delivering new cars to the quayside. On Saturday 14 May 2022, No. 66116 waits at the docks while its train is unloaded. It will later return the empty cartics to Didcot where the rake will stable for the weekend.

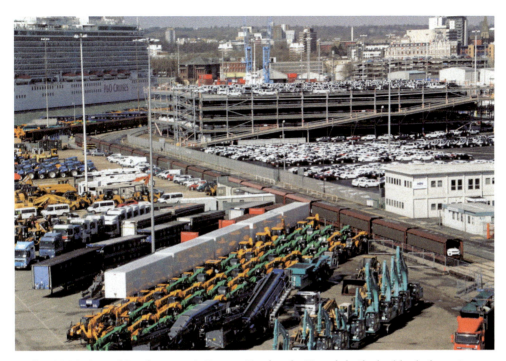

In this 2016 view of Southampton's Eastern Docks, the French-built double-deck cartics can also be seen in the process of being unloaded at the quayside. The photo is taken from the nearby cruise terminal.

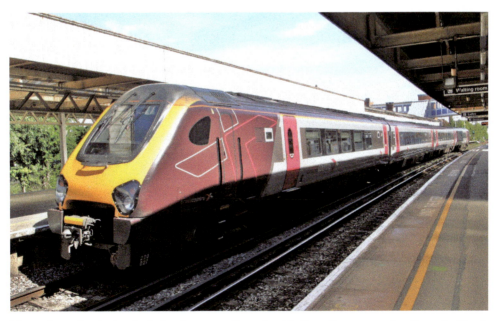

The main station in the city is Southampton Central, with CrossCountry services from the North West of England either terminating here or running through to Brockenhurst and Bournemouth, rather than Poole as in the past. On 16 July 2014, Voyager No. 220027 stands in the platform at Southampton Central.

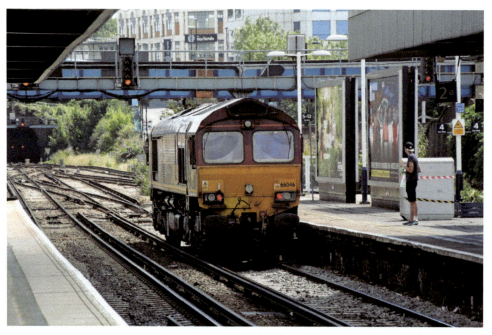

Much of the non-passenger traffic arriving and departing the wider Southampton area is forced to pass through Central station using the city's tunnelled double track section. DB Cargo's No. 66046 waits for the road as it stands at a red signal at the platform end.

The suburban station at Millbrook lies approximately a mile to the west of Central station. The unstaffed station consists of an island platform serving the two slow lines only. Access to the station is via a footbridge linking it to Millbrook Road West.

Southampton – Around the City and Suburbs

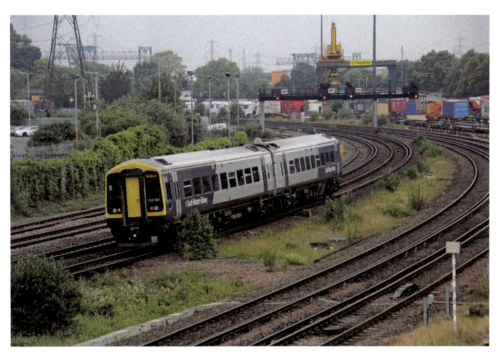

The station is served by the Class 158 stopping service between Southampton and Salisbury. On 27 June 2021 new liveried SWR unit No. 158887 pulls away on a service to Salisbury.

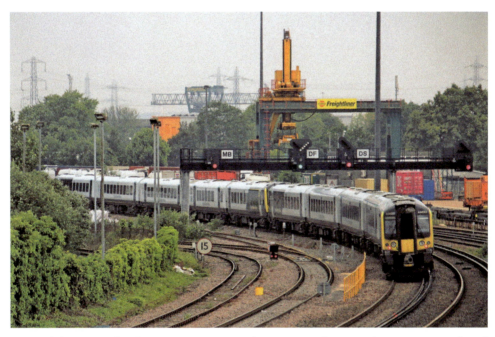

Meanwhile, SWR's flagship passenger services between London Waterloo, Bournemouth and Weymouth pass through without stopping. A ten-car train with unit No. 444003 on the rear passes the nearby Freightliner terminal. The freight traffic to the west of Southampton is covered in the next section.

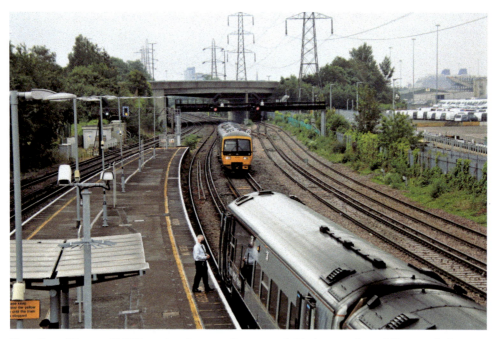

First Great Western (FGW) services between Portsmouth Harbour and Cardiff Central also pass without stopping. One of FGW's Turbo diesel multiple units, No. 165135, passes Millbrook station on a service to Cardiff.

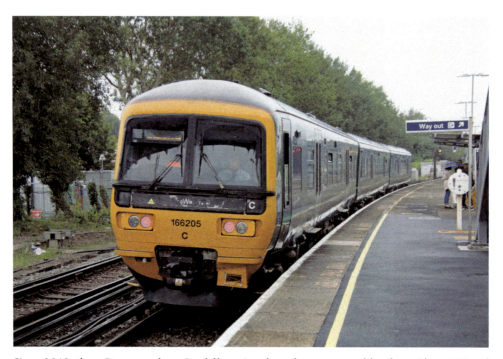

Since 2019, these Portsmouth to Cardiff services have been operated by these Class 165 and Class 166 'Turbo' units. On a June 2021 day, No. 166205 passes through the island platform on a service to Portsmouth Harbour.

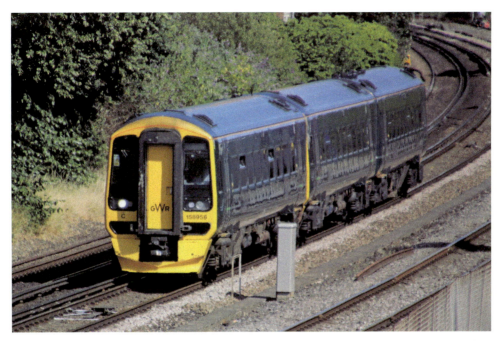

Beyond Millbrook, the passenger services pass the main Freightliner hub at Maritime, which is examined in detail in the next section. On 15 July 2018, before the introduction of Turbo units, a First Great Western service in the hands of No. 158956 passes the Maritime terminal on a service to Cardiff Central.

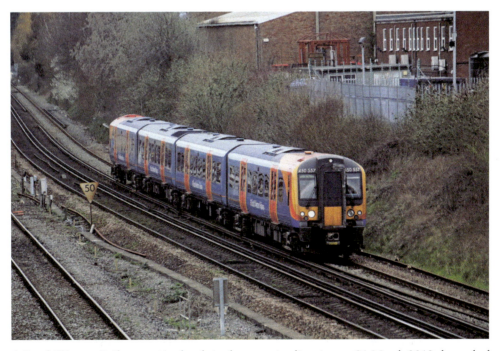

A South Western Railway service heads in the opposite direction on 21 March 2019, formed of four-car unit No. 450557. It is working a Bournemouth to Winchester stopping service.

The next station to the west is at Redbridge. This is the junction for the SWML towards Bournemouth and Weymouth, and the line north to Romsey and Salisbury. As with the other stations west of Southampton, it is served by the hourly SWR stopping service between Southampton and Salisbury.

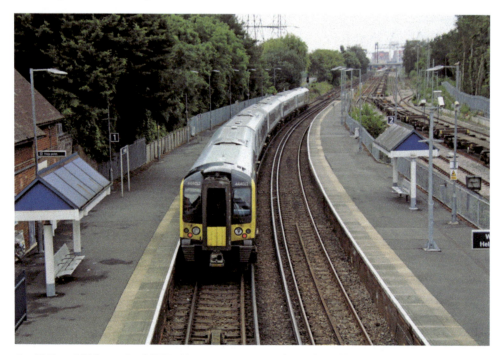

On 20 June 2021, a pair of SWR Class 444 units pass through Redbridge on a London Waterloo service. Unit No. 444012 is on the rear. A rake of Freightliner flat wagons is stabled to the right of the picture.

Southampton – Around the City and Suburbs

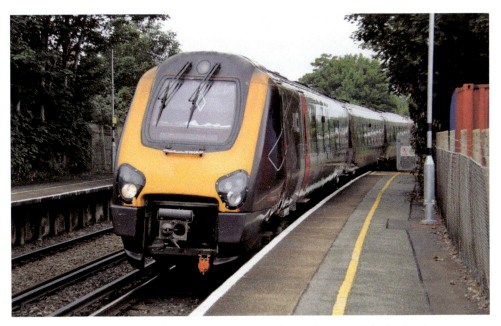

The final station featured in this section is at Totton, located just outside the Southampton city boundary and before the line runs westwards through the New Forest to Brockenhurst and Bournemouth. In 2021, Voyager No. 221123 passes through the station on a CrossCountry service from Bournemouth to Manchester Piccadiily.

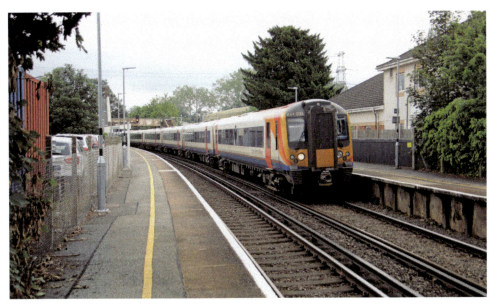

SWR unit No. 444036 is heading in the opposite direction on 20 June 2021, on a London Waterloo to Weymouth service. Totton is a junction for the freight-only branch line to Marchwood (Ministry of Defence base), Hythe and Fawley. A reinstatement of passenger services on the branch, which skirts the western side of Southampton Water, is under consideration. Although the MOD base at Marchwood is still rail served, the oil traffic to and from Fawley was lost to rail long ago.

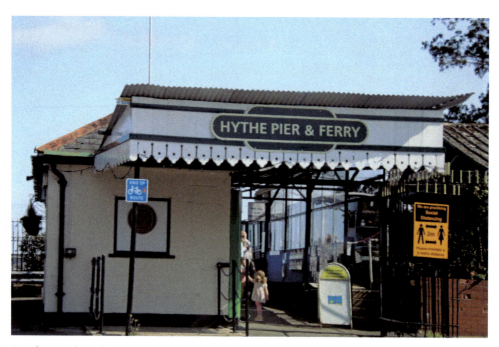

For the time being, passenger train interest to the west of Southampton Water is restricted to the Hythe Pier Railway. A regular Blue Funnel ferry service across Southampton Water links Hythe with the city of Southampton. That company currently operates the connecting rail service on the Hythe side of their ferry operations.

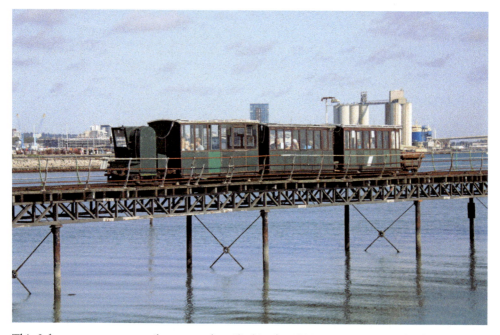

This 2 feet, narrow-gauge railway was electrified in the 1920s. It operates via third rail current, over a distance of around 600 metres, along the pier. It is said to be the oldest pier railway in continuous operation in the world today.

Freightliner's Hub at Southampton Maritime and Millbrook

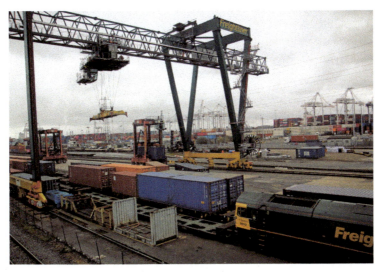

Freightliner Ltd was originally a British Government-owned business primarily concentrated on the UK's sea ports, carrying goods by rail. It was later to become part of Railfreight Distribution just before rail privatisation. That privatisation led to a management buyout around twenty-five years ago. Since then, the company has diversified into other freight markets, but container traffic remains at its core. This is a view of their Maritime terminal in 2018.

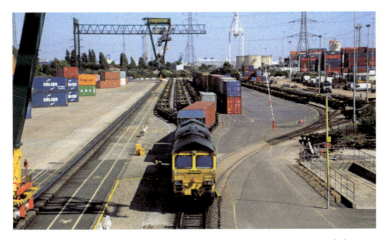

Freightliner's fleet of Class 66 locomotives remains the mainstay of their traction fleet. Their services are primarily centred on the container ports of Felixstowe and Southampton. These two major ports, and, more recently, London Gateway, are connected to a number of destinations around the UK through regular container-carrying rail services. On 15 July 2018, No. 66508 is seen in the company's Maritime terminal.

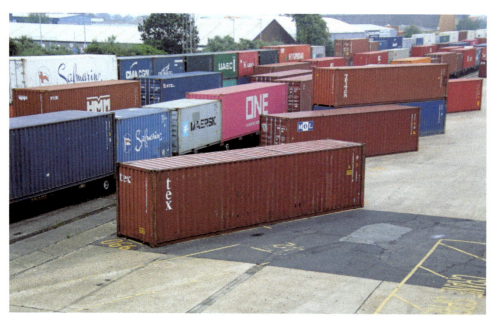

The scale of operation at Southampton Maritime is impressive, with an estimated 30 per cent of all containers at Southampton moved onward by rail. Freightliner claim to move over ¾ million containers per year from the ports of Felixstowe, Southampton and London Gateway.

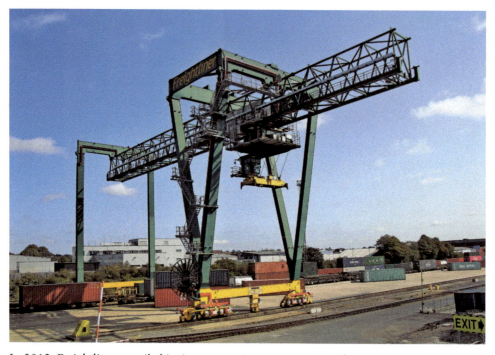

In 2012, Freightliner unveiled its investment in two new cranes for container movements at its Southampton hub, coinciding with the fortieth anniversary of operations. The cranes were named *Freightliner Fortis 15-10-2012* and *Freightliner Agilitas 15-10-2012*. Fortis represented strength and power, while Agilitas represented ease of movement and efficiency.

Freightliner's Hub at Southampton Maritime and Millbrook 87

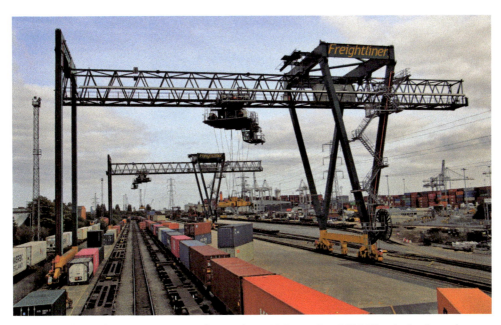

This scene shows the Maritime terminal at work on 11 September 2020. The docks themselves are out of the picture on the right, the terminal in the centre and the South Western Main Line to the left, with a CrossCountry Voyager heading towards Southampton seen on the extreme left horizon.

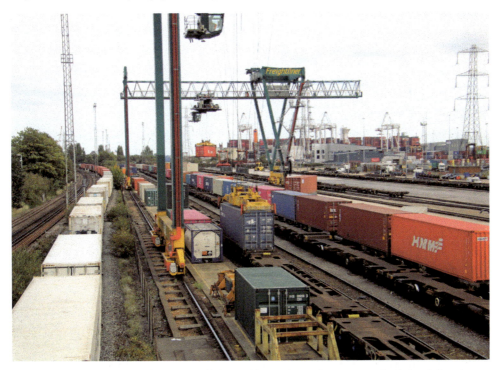

In this view on the same day, a Freightliner Class 66 can be seen on the left of the picture waiting to head towards Southampton and then to the north with a loaded train. The subject of containers by rail in the UK was explored in much more detail in an earlier title of mine.

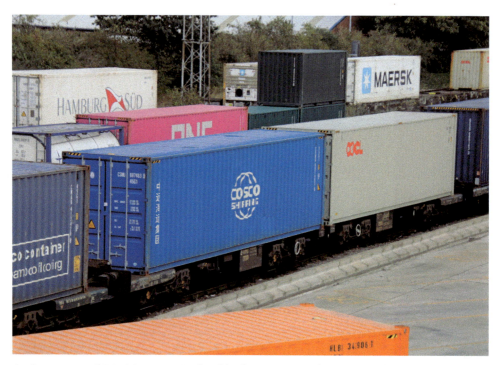

A glance around Maritime terminal is like browsing a 'who's who' of shipping container companies. In this busy scene in September 2020, for example, COSCO and OOCL containers are seen loaded side by side on Freightliner flat wagons. The business bond between Freightliner and the latter company extended to the naming of a Class 66 in their honour. Freightliner's No. 66534 carries the name *OOCL (Orient Overseas Container Line)*.

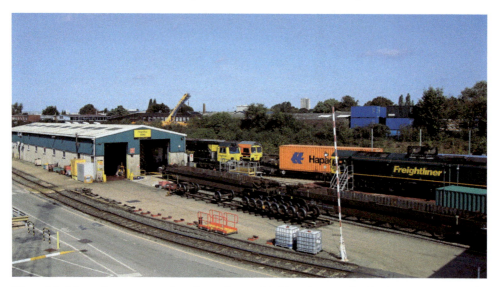

These Maritime photos were taken from the road bridge close to the dock gates. Turning the camera round 180 degrees and the view from the opposite side of the bridge is of the Freightliner depot of the same name. This is Freightliner's hub for servicing their loco fleet and also wagon repairs.

Freightliner's Hub at Southampton Maritime and Millbrook 89

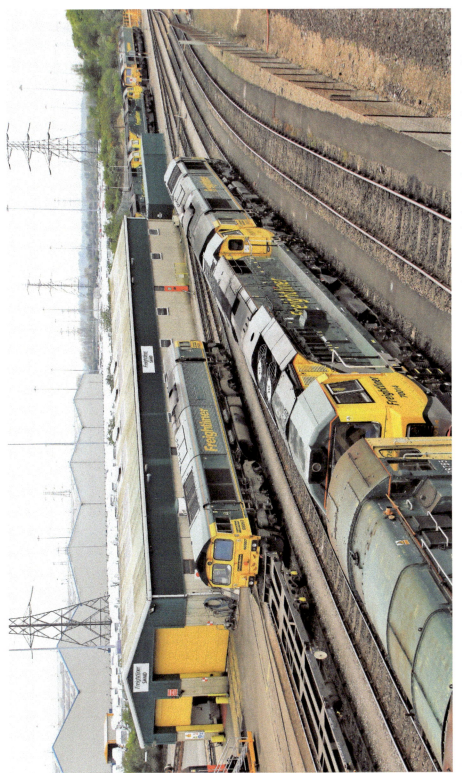

The Freightliner depot handles servicing and maintenance of the company's extensive fleet of Class 66 and Class 70 locos. It is also the stabling point for its Class 08 diesel shunters. This September 2020 view of the depot motive power includes Nos 08757, 70014, 66592 and 66957.

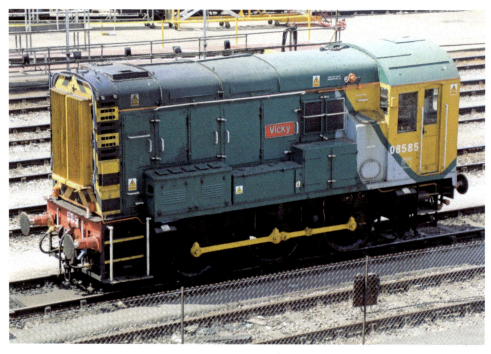

Several Class 08 diesel shunters, carrying the company's own Freightliner livery, have seen use at Maritime during the privatised era. These include No. 08585 *Vicky*, seen on the depot on 14 July 2018.

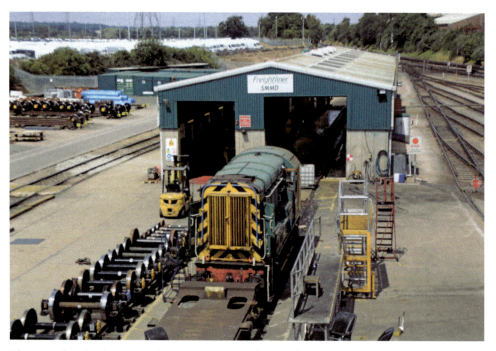

The same day, the depot was also home to sister Class 08 shunter No. 08530. It is seen stabled in the area reserved for wagon repair and maintenance.

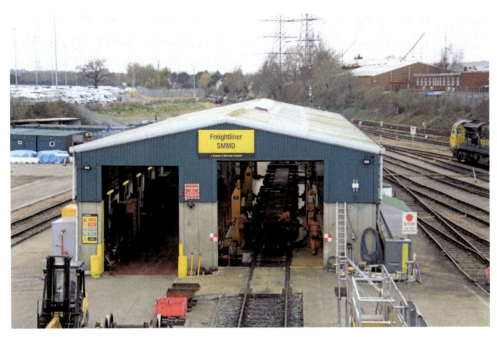

This March 2019 view shows the Freightliner wagon repair area in action, with several of the company's substantial fleet of container flat wagons in the maintenance depot.

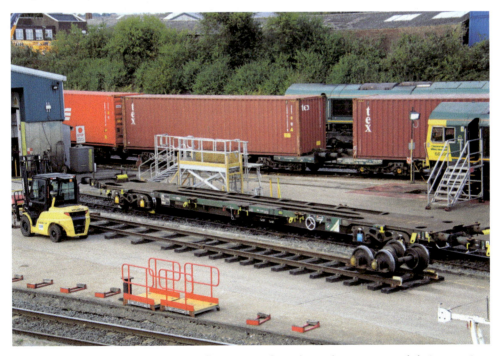

Freightliner's fleet of FSA/FTA type flat wagons have been the mainstay of their container operations since the early 1990s. French wagon builders Arbel Fauvet constructed a total of 700 wagons, the majority of which remain in use to this day. FSA wagon number 608139 is seen on Maritime in this September 2021 view.

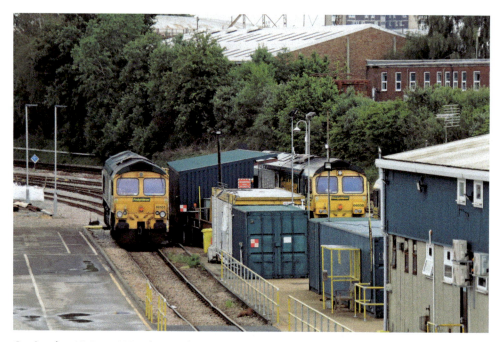

On Sunday 20 June 2021 the Southampton Maritime stabling point was home to Nos 66555 and 66505. Both locos were not required with the nearby docks closed for the weekend. It is also an opportunity for the depot to carry out any routine exams and maintenance.

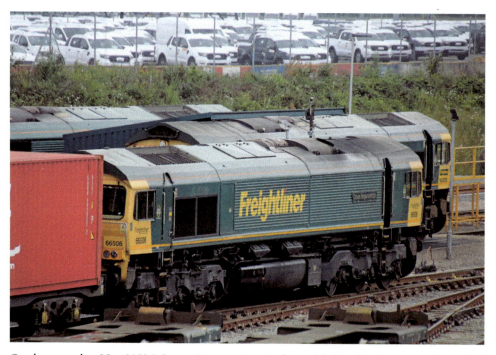

On the same day, No. 66506 *Crewe Regeneration* is also stabled in the depot complex. It had previously worked into the Southampton area on a returning container service from Cardiff Wentloog and is awaiting its next allocation in readiness for the start of the next business week.

Freightliner's Hub at Southampton Maritime and Millbrook

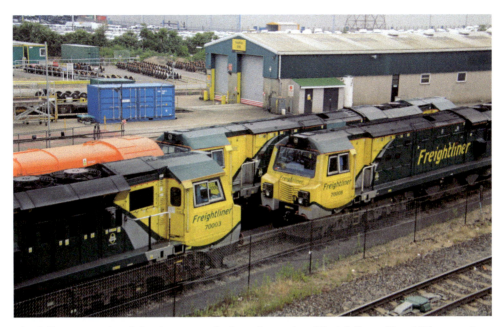

The following weekend the depot was the base for a trio of Freightliner Class 70 locomotives, namely Nos 70003, 70008 and 70004. While No. 70004 was undergoing maintenance, No. 70007 would next leave for the container terminal at Trafford Park, Manchester, and No. 70008 for Lawley Street, close to Birmingham's city centre.

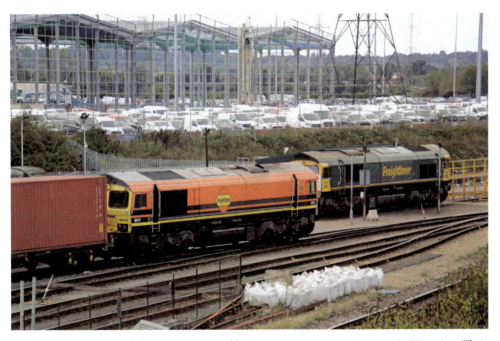

In February 2015, Freightliner was acquired by American company Genesee & Wyoming. Their corporate livery has gradually been applied to examples of the Freightliner locomotive fleet, including their Class 66 No. 66419. It is seen on Maritime depot on 11 September 2020, stabled alongside No. 66522, which is still carrying the contrasting Freightliner green and yellow livery.

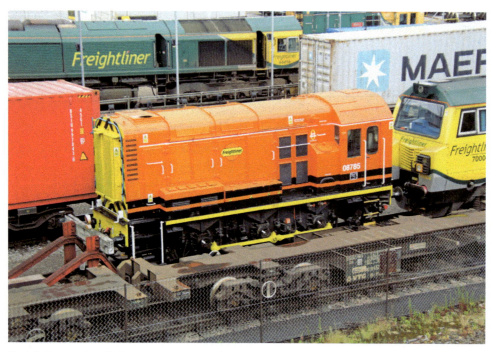

Freightliner's diesel shunter No. 08785 had also recently received a Genesee & Wyoming corporate repaint when it was seen stabled at the Maritime depot complex on 20 June 2021.

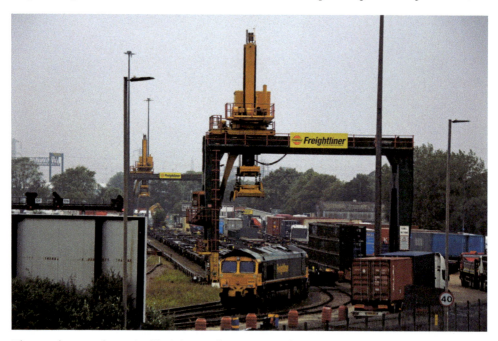

The nearby complex at Millbrook, Southampton, is also used by Freightliner for additional wagon storage and maintenance. This is the view of the terminal, taken from the footbridge at nearby Millbrook station. On 27 June 2021, Class 66 locomotive No. 66515 is seen in the foreground.

Freightliner's Hub at Southampton Maritime and Millbrook

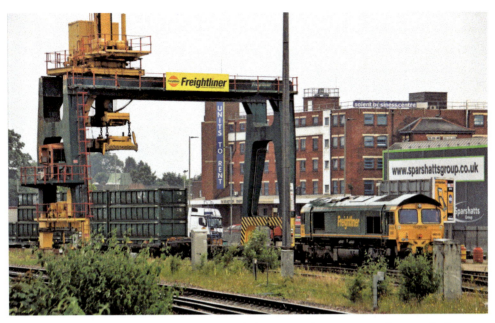

At weekends when the docks are closed and the terminal at Maritime has reached wagon capacity, the Millbrook facility is also used as an overflow. This Saturday view shows No. 66515 stabled on the terminal, having worked into the area the previous day on a returning Freightliner working from the Lawley Street terminal in Birmingham.

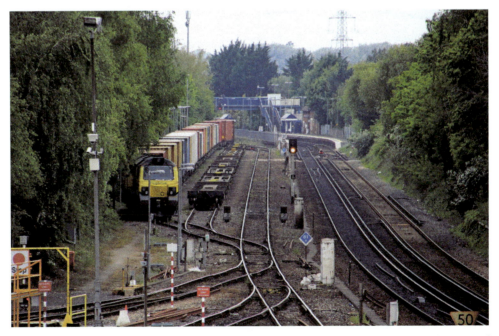

Additional Freightliner wagon stabling is available close to Redbridge station to the west of Maritime terminal. In this view taken on 30 April 2017, Class 70 locomotive No. 70019 is stabled along with its rake of wagons. In the distance the suburban station of Redbridge can be seen.

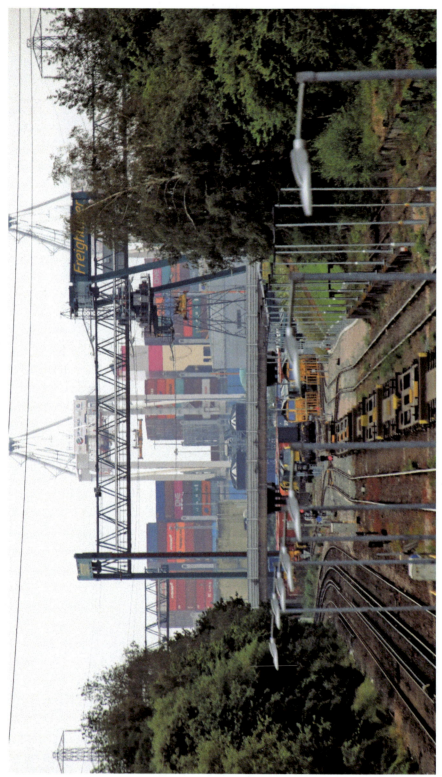

The vast scale of the shipping container traffic at Southampton is clearly seen in this final photo of the Maritime complex taken in June 2021 from the footbridge at Redbridge station. The Class 08, Class 66 and Class 70 locos are stabled on the depot, with the wagons in the container terminal beyond the road bridge. The huge dockside pile of stacked containers can be seen beyond.